IMAGES
of America

ROEBLING REVISITED

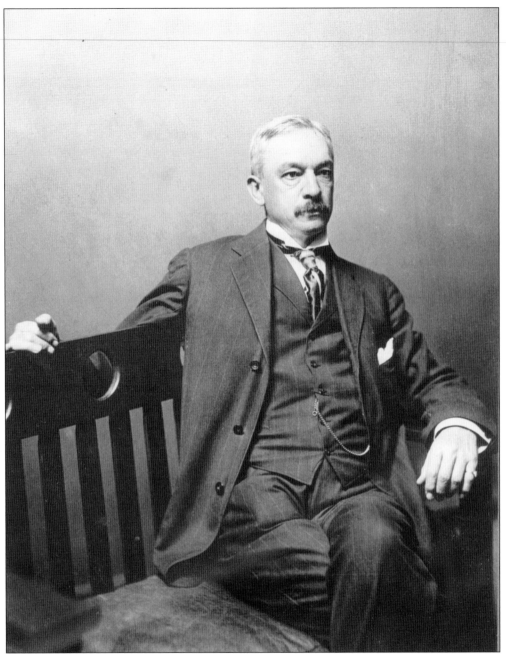

Charles G. Roebling was born in Trenton on December 9, 1849. He attended public school in Trenton and private school on Staten Island, New York. In 1871, Roebling graduated from Rensselaer Polytechnic Institute. In the late 1870s, he became the president of John A. Roebling's Sons Company. In 1905, he supervised the design and construction of the village of Roebling with exceptional care. The buildings, landscaping, and street layout were detailed to his specific plans. (Courtesy Tyson family.)

On the cover: Harvey Van Ness is in the crane with coworkers in the steel mill Open Hearth in February 1954. (Courtesy Louis Borbi.)

IMAGES
of America

ROEBLING REVISITED

Friends of Roebling

ARCADIA
PUBLISHING

Published by Arcadia Publishing
Charleston SC, Chicago IL, Portsmouth NH, San Francisco CA

Printed in the United States of America

Library of Congress Catalog Card Number: 2006940201

For all general information contact Arcadia Publishing at:
Telephone 843-853-2070
Fax 843-853-0044
E-mail sales@arcadiapublishing.com
For customer service and orders:
Toll-Free 1-888-313-2665

Visit us on the Internet at www.arcadiapublishing.com

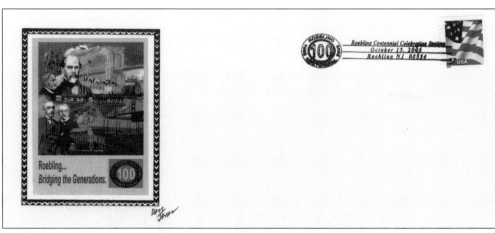

Local artist Don Jones created the collage highlighting Roebling family members and their accomplishments on this first cover envelope. John A., Washington A., Ferdinand W., and Charles G. Roebling are depicted with the Brooklyn and Golden Gate Bridges. The public could purchase the commemorative envelope with the hand-stamped Roebling cancellation on October 15, 2005. (Courtesy Rose M. Menton.)

CONTENTS

ACKNOWLEDGMENTS

We could not have completed this book without the assistance and knowledge of many people. We want to thank Ronald Agoes and AnnMarie Korinko Agoes, Elizabeth Bajzath, Louis Borbi and Carol Tapper Borbi, Joseph Bordas, Helen Bartha Bordash, Kay Bradshaw, R. Warren Brown, Marius Budiu, Betty Lou Bunnick, Michael Bunnick and Maryann Bordas Bunnick, Pastor and Mrs. Iosef Chereches, Ann Danley, Nancy Bartha D'Annunzio, Margaret Dezsy, Peg Dotson, Carol Chanti Eckman, Steve "Fuzzy" Fazekas, the late Elizabeth Garbely, Richard Glass, the late Bill Gyenge, Marion Hankins, Georgiana Bordash Harkel, Rev. Garey Hope, Hungarian Reformed Church of Roebling, Lula Boone Jenkins, Don Jones, the late Philip "Dutchie" Lynch, Maryann Marian, Irene Simonka Masich, Helen Matis, Margo Miller Mattis, Marion McDowall, Harold "Bud" and Jean Miller, Ted Mitre, Mary Arnold Montalto, the late Helen Nagy, Paul and Janice Ordog, Sandy Paglione, Joseph Pinto, Helen Potpinka, Earl and Dorothy Richardson, Arcadia editor Dawn Robertson, Daria Kate Sbraccia, Ellen Suydam Scott, Matthew M. Scott, Michael M. Scott, Bert S. Somogyi, Frank Todash, Christian Varga, Corinne Varga, Dyanne Varga, Joseph Yeager, and Mary Yurcisin.

Also we would like to credit the following sources used in researching this book: the *New York Times*; the *Times of Trenton*; the *Burlington County Times*; the *Register-News*; American Society of Mechanical Engineers 93rd National Historic Mechanical Engineer Landmark Program dated October 21, 1989; *Spanning the Industrial Age—The John A Roebling's Sons Company, Trenton, New Jersey 1948–1974*; Clifford W. Zink and Dorothy White Hartman; Trenton Roebling Community Development Corporation; and Trenton Printing Company, 1992.

Last but not least, we want to thank everyone who made our first book, *Roebling*, the success it is. Time and time again, the residents of Roebling have showed their interest and pride in their village, and we are grateful for all your support.

INTRODUCTION

Over 100 years ago, Charles G. Roebling built what is now known as a company town. By constructing a series of buildings, he created an entire steel-making facility 10 miles south of his main mill in Trenton. He expanded the John A. Roebling's Sons Company to make the wire rope needed for bridges, elevators, ski lifts, and many other uses. Roebling built a village to house the workers needed for the mill and made sure that the goods and services the workers needed were available.

Through 1946, the village of Roebling remained the same. The villagers went to the mill to work, shopped at the general store and the other ethnic groceries that were just outside the perimeter of the village, and worshiped in its many churches. They lived in homes that the John A. Roebling's Sons Company provided for them at a cost of $8.50 to $24 per month, depending on the size of the house. The residents of the village always showed their civic pride.

After World War II, life in Roebling changed drastically.

In January 1947, the John A. Roebling's Sons Company decided to sell the homes to the residents of the village. The cost of the homes was from $3,000 to $6,500 with the three largest homes along Riverside Avenue costing $16,000. The village of Roebling became part of Florence Township, and the township took over the public works and the education systems.

In January 1952, the Roebling family sold the businesses, plants, and inventories of the John A. Roebling's Sons Company to Colorado Fuel and Iron Corporation for $23 million. At the time, Colorado Fuel and Iron Corporation was the ninth-largest steel producer in the country. Two members of the Roebling family stayed with Colorado Fuel and Iron Corporation. Charles Roebling Tyson, who was the last president of John A. Roebling's Sons Company, served as executive vice president until 1959, and Ferdinand W. Roebling III served as the senior vice president of engineering until his retirement in 1965.

In June 1974, Colorado Fuel and Iron Corporation closed the Roebling mill without warning. Approximately 1,400 workers lost their jobs. Suddenly the one thing that united the village was gone for good. There were attempts to reopen the mill under different owners. Alpert Brothers of Philadelphia bought the mill with financing from the U.S. Economic Development Authority and restored operations for one and a half years. Then in 1979, a joint venture bought the mill site and called the company John A. Roebling Steel Corporation, or JARSCO. The mill only remained open for one year, and the site was closed for good in 1982.

In 1983, the former mill was declared a Superfund site by the U.S. Environmental Protection Agency. Eventually Florence Township became the owner of the site.

In spite of all the problems, life did continue in Roebling. In 1989, the village celebrated Founder's Day with a parade and other events. St. Nicholas Greek Catholic Church has held

its ethnic festival every year with homemade delicacies such as stuffed cabbage, pierogie, and *kolbasz*, or Hungarian spiced sausage. The Roebling Garden Club began a tradition to plant geraniums at the Main Street Circle to honor loved ones on Memorial Day.

The New Jersey Transit RiverLine started service from Trenton to Camden in March 2004. The light-rail transit system on the route used originally by the Camden-Amboy Railroad now has a very busy stop in Roebling.

In 2005, Roebling celebrated its 100th anniversary with a series of events. There was Muffins on Main Street, which brought the community and civic groups together. And in May, the rededication of the World War II honor roll took place, along with the Stuffed Cabbage Cook-off, a vespers service, and the unveiling of the 100th anniversary plaque on the monument in Roebling Park. During the Patriotic Day celebration in July, the annual parade went through the village and ended with fireworks launched from the former mill site for the enjoyment of audiences in Roebling Park and the surrounding area. The year ended with the Roebling Centennial Gala, which was held at the Roebling Auditorium with over 200 guests in attendance.

Going into its next 100 years, there is reason for hope and optimism. In January 2007, the Florence Township Council entered an agreement with Preferred Real Estate of Conshocken, Pennsylvania, to sell the mill site for development. The new owner envisions office space, high-tech manufacturing, and retail establishments. Recreational access to the Delaware River is also planned. The goal is to develop the area for the betterment of the community and the surrounding area.

A life-size statue of Charles G. Roebling is scheduled to be unveiled in 2007. The Roebling Garden Club sold pavers and received corporate donations to raise the funds needed for the statue. The statue will be erected on the Main Street Circle and will be facing the main gate of the mill.

We honor past, present, and future residents of Roebling. Many of the past residents came to Roebling from other countries in search of better opportunity. Many of the present residents are former mill workers who still make Roebling their home. In the future, we hope the mill site will be the source of great opportunity and that residents continue the civic pride Roebling has always had.

There are many memories and events about the village of Roebling that are fading as time goes on. We wrote *Roebling Revisited* because it is worthwhile to learn what has happened over the past 100 years. Charles G. Roebling gave us the village—the residents gave us the memories. Our book shows over 200 snapshots of the people, events, activities, and traditions of the village. We are honored to be given access to family scrapbooks and photograph albums that give us a glimpse of what our home, Roebling, is to us.

<div align="center">

Friends of Roebling, in association with the Roebling Garden Club
Paul Varga, Loretta M. Varga, Joseph B. Varga,
Joseph Varga, Michelle Varga Scott, and Rose M. Menton
February 2007

</div>

One

ROEBLING'S EARLY BEGINNINGS THROUGH 1940

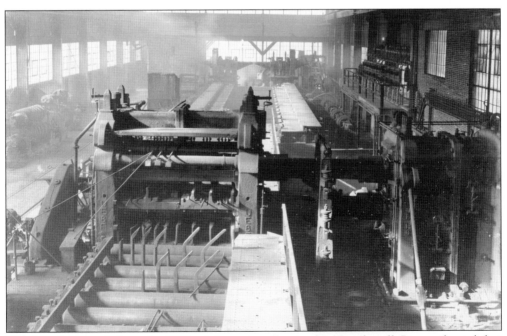

This is a photograph from the 1920s of the main rollers in the 35-inch mill. Pieces of metal that are inside the rollers were used to turn ingots in preparation for the next stage. Rolls at the left are being cut to size. (Courtesy Louis Borbi.)

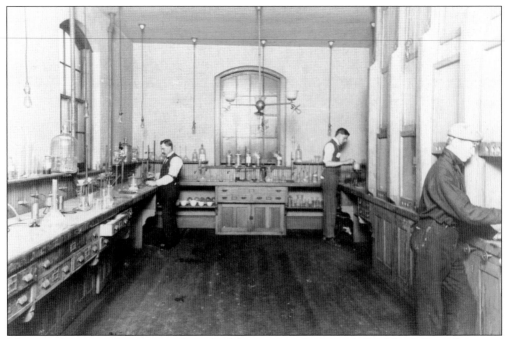

Three workers are testing materials in the laboratory at the John A. Roebling's Sons Company around 1925. (Courtesy Louis Borbi.)

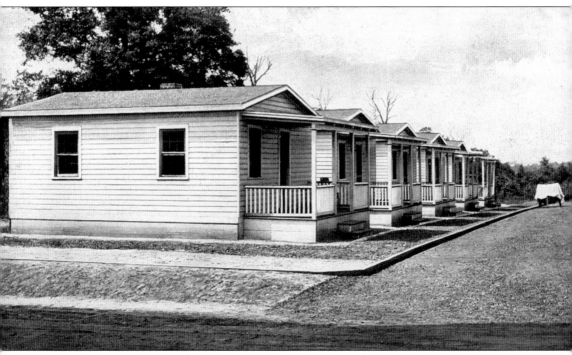

West End Avenue in Roebling is pictured in the postcard that was published by John A. Roebling's Sons Company. These homes were built in Bristol, Pennsylvania, and floated across the Delaware River to their site near the Trinity United Methodist Church. They were used

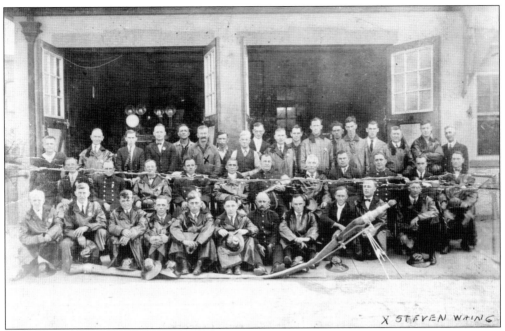

X STEVEN WAING

Here are John A. Roebling's Sons Company firemen in the 1920s. The man marked with the X is Steven Waing, who worked in the bridge shop for approximately 40 years. In the first row are John Sabo, Peter Matis, and Bruce Hubley, among others. (Courtesy Helen Matis.)

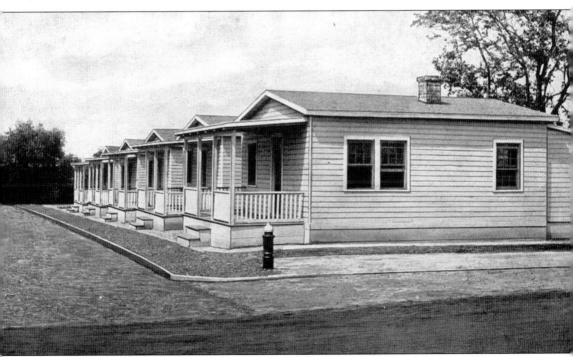

as temporary housing for newlyweds. Then as housing in the village became available, the newlyweds moved on. (Courtesy Rev. Garey Hope and Louis Borbi.)

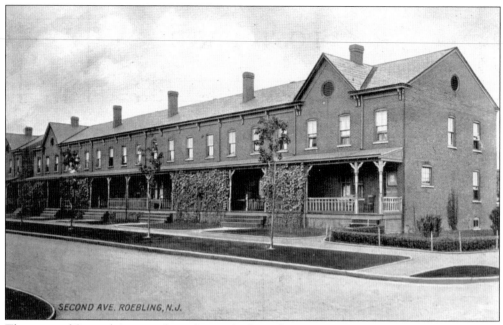

This view of Second Avenue shows homes built in the 1920s. Notice how several homes have vines growing up the front porch for shade. (Courtesy Louis Borbi.)

This is a photograph of Roebling mill homes at the corner of Seventh Avenue and Knickerbocker Avenue (now known as Hornberger Avenue). Note the trolley tracks in the foreground. The trolley went from Trenton to Camden. A curtain stretcher is located at the corner of the first house. (Courtesy Louis Borbi.)

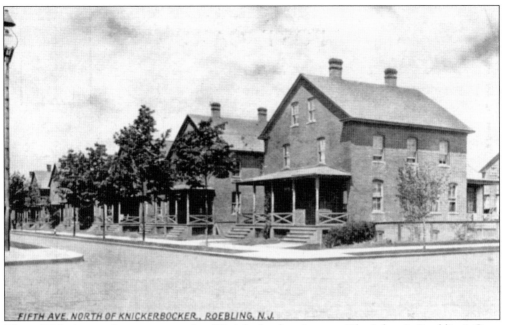

These Fifth Avenue homes are north of Knickerbocker Avenue. The John A. Roebling's Sons Company published postcards showing the views of the village. When this 1920s postcard was mailed, the required postage was 1¢. (Courtesy Louis Borbi.)

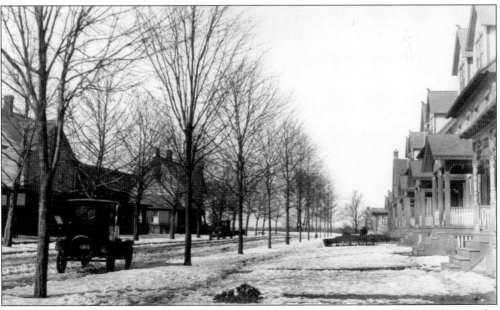

This view shows Sixth Avenue looking toward Roebling Park on a snowy winter day. Notice the size of the trees and the 1920s-era car. (Courtesy Louis Borbi.)

Juliana Marian, mother of Alex "Cremo" Marian, stands with Mrs. Nyalka (left) in the 1920s. They are standing in the backyard of 131 Third Avenue. (Courtesy Maryann Marian.)

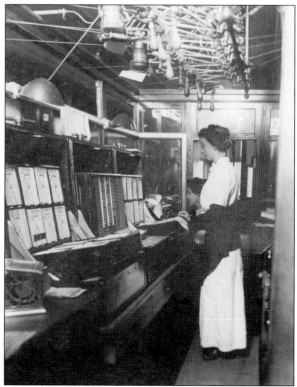

Here is the Roebling General Store in the late 1900s. Emma Weeks Shaw is standing, and Adela McCabe Danley is seated. The ladies worked in the store's billing department. (Courtesy Kay Bradshaw.)

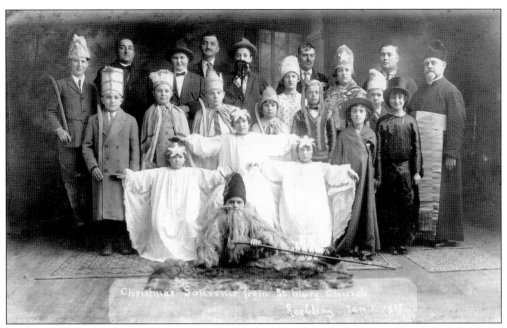

Here it is Christmas in 1917 at St. Mary's Romanian Church. John Borbi is on the left in the middle row. Fr. Aurel Bungardean is the priest at the far right. Ted Mitre is in the white pointed hat in the second row, seventh person from the left. (Courtesy Louis Borbi.)

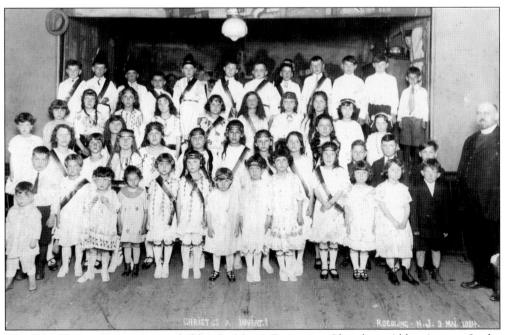

The 1924 Christmas pageant was held at St. Mary's Romanian Church on Alden Avenue. In the first row, Louis Borbi is on the left with the tie, John Buhan is without the tie, and Gus Bonatz is at the far right. Irene Borbi is the fifth person from the left in the third row, and the fourth row includes Mike Mitre (second from left), Ted Mitre (third from left), and John Borbi (seventh from left). (Courtesy Louis Borbi.)

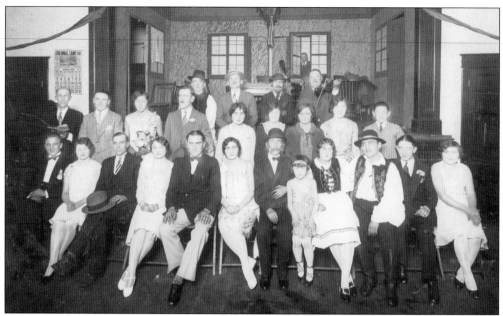

A play called "Sardi Haz Eloadta," or "Little Town," was held at the Hungarian Home on Norman Avenue on April 1, 1929. Among those pictured in the first row, Mary Gilanyi is seated fourth from the left and Mr. and Mrs. Kovach are on her right, ninth from the left is Matilda Todash, and tenth is Joe Halasz. In the middle row are, from left to right, Menyius Varga, Steven Bajzath, unidentified, unidentified, Margaret Hadorics, unidentified, Mary Ford, Julia Deszeran, and Al Stefan. (Courtesy Elizabeth Bajzath.)

This 1930s photograph was taken in a Roebling backyard with its wood and chicken wire fence and neatly planted bushes. (Courtesy Rose Cardis.)

This photograph shows the Hankins family in front of their home at 18 Eighth Avenue in 1924. From left to right are Raymond B., Eloise, Philip, and Edith. Raymond worked in the employment office of John A. Roebling's Sons Company for many years. (Courtesy Marion Hankins.)

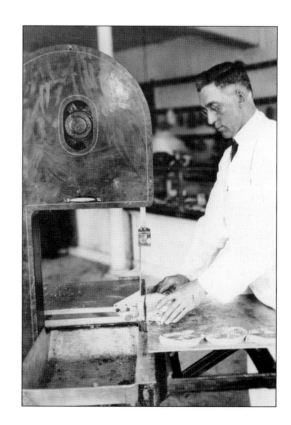

A butcher prepares fresh cuts of meat at the Roebling General Store around 1923. (Courtesy Louis Borbi.)

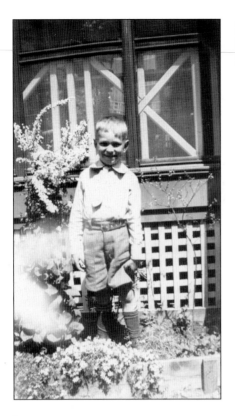

Paul Varga, in knickers, tie, and high socks, stands in front of his home on Fourth Avenue in 1938. (Courtesy Paul and Loretta M. Varga.)

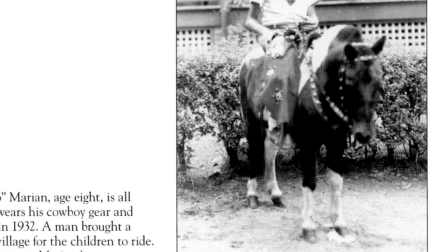

Alex "Cremo" Marian, age eight, is all smiles as he wears his cowboy gear and rides a pony in 1932. A man brought a pony to the village for the children to ride. (Courtesy Maryann Marian.)

Dressed up in their Sunday outfits, from left to right are Robert Carty Arnold, Mary V. Arnold Montalto, and Frank "Specks" Arnold. In the background are a washtub and clothes prop. This image was taken in the 1930s. (Courtesy Mary Arnold Montalto.)

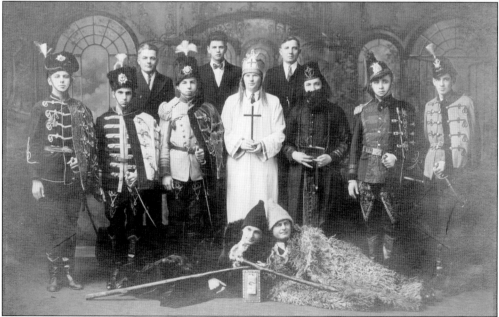

The Goombashes from St. Mary's Romanian Church pose for this photograph in 1935. The Goombashes provided entertainment as they visited homes on Christmas Eve. Among those in the second row are Mike Dragon (third from left), Louis Borbi (fifth from left), and Ted Mitre (far right). The third row includes Mike Mitre (center) and Louis Borbi (right). (Courtesy Louis Borbi.)

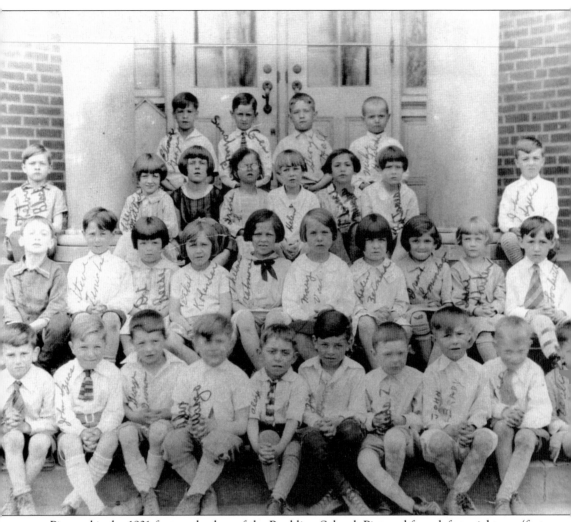

Pictured is the 1931 first-grade class of the Roebling School. Pictured from left to right are (first row) Phil Stone, John Szucs, George Dimon, Alex Wargo, Alex Marian, Joe ?, Reds Z., John Brady, Ted ?, and Walter Wargo; (second row) unidentified, Steve Tinick, Dot Reese, Ethel Kolendar, Thelma Ashmore, Mary Vaet, Helen Zitnick, Irene Simonka, Irene Schuler, and ? Lockett; (third row) Kelvin Black, Lillian Matlack, unidentified, Irene S., Helen ?, Florence ?, B. Jones, and John Szucs; (fourth row) Elmer Gyenge, G. Simshack, George Hall, and Mike Hatalovsky. (Courtesy Irene Simonka Masich)

Erik Andreason is pictured boxing in the Pest House about 1935. The Pest House was located behind the present Veterans of Foreign Wars hall on Tenth Avenue and Main Street. It had various uses, including an area to quarantine residents and, later, a gymnasium that the village boxers used. (Courtesy Louis Borbi.)

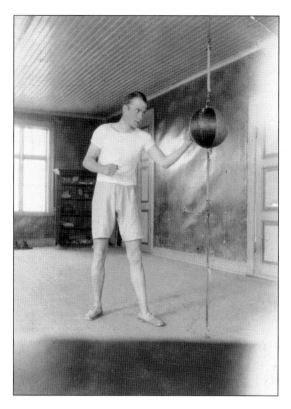

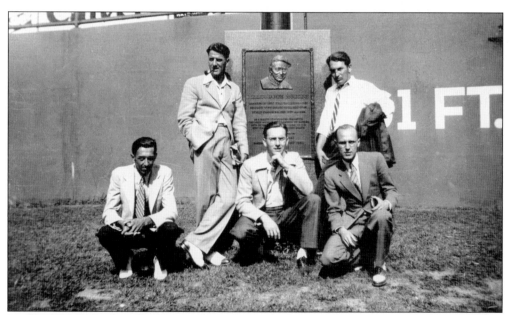

Roebling residents hit the Big Apple and attended the All-Star Game at Yankee Stadium on July 11, 1939. In front of the Miller Huggins monument, from left to right, are Alexander "Lefty" Kopanyi, George "Moe" Moyer, Ed Keating, Bob Abrams, and Sam Phieffer. (Courtesy Louis Borbi.)

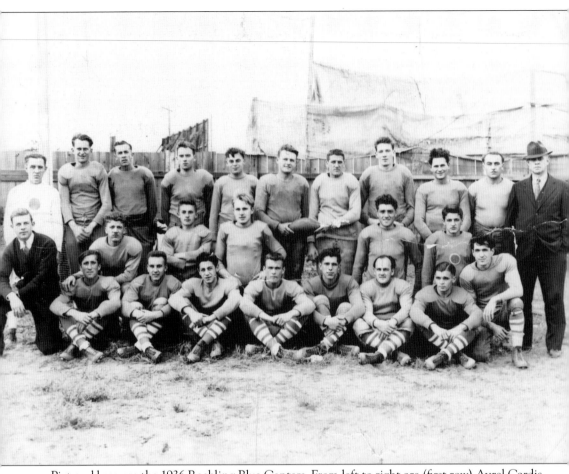

Pictured here are the 1936 Roebling Blue Centers. From left to right are (first row) Avrel Cardis, John Corda, Pete Cesaretti, ? Molnar, Joe Ordog, George Eckman, Mike Molnar, and "Dad" Varava; (second row) Joe Csercsevits, George Dragos, George Opre, Steve Ivins, Steve Kovacs, and Pete Litus; (third row) Bruce Hubley, Ray Arnold, Tony Pukenas, Mike Keating, George Bordash, "Fats" Sholeack, John Moyer, Lester Danley, John Opre, Mickey Bordash, and Carl Bellejeau. (Courtesy Louis Borbi.)

In 1933 on Easter Monday, 17-year-old Elizabeth Rusnak and 18-year-old Joseph Bordas had their pictured taken in Roebling Park. They married in 1938 and had two businesses on Alden Avenue for many years. In the background is the water tank for the John A. Roebling's Sons Company. (Courtesy Maryann Bordas Bunnick.)

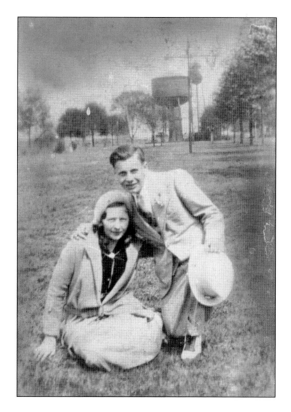

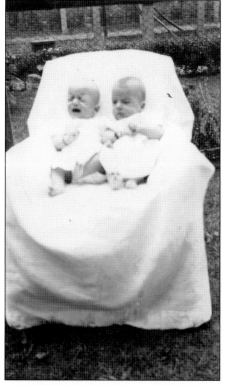

Nine-month-old twins Louis (left) and Michael Bunnick enjoy their backyard in 1942. (Courtesy Maryann Bordas Bunnick.)

23

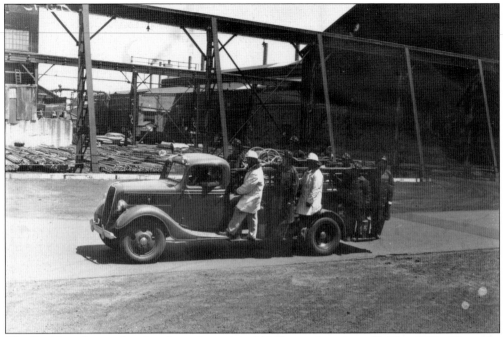

The Roebling fire truck rides along the two-inch billet yard at the mill. The 1930s Chevrolet truck was part of the mill's fire brigade, which was located at the ambulance garage on the mill site. (Courtesy Louis Borbi.)

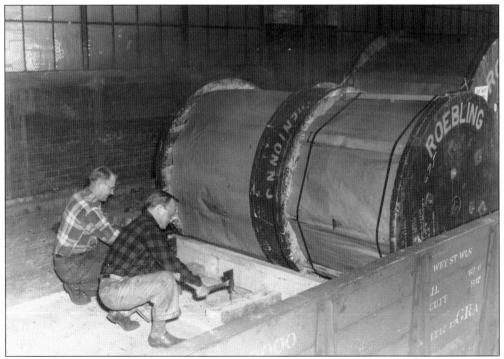

Two workers prepare the wire product for shipping in the late 1930s. Notice the Roebling name on the right side of the reel. (Courtesy Louis Borbi.)

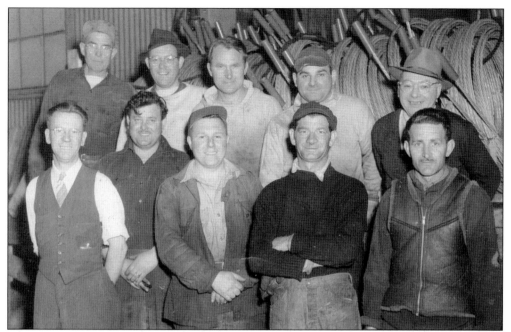

The John A Roebling's Sons Company had the world's largest testing cable tract. The workers pictured in this 1942 photograph, from left to right, are (first row) Bob Martin, Joe Horvath, Len Olschewski, Elmer Bonner, and Oliver Wood; (second row) Oscar Parker, Al Kish, Steve Ivenz, Eugene Sclavi, and Eddie Kerns. (Courtesy Louis Borbi.)

This photograph shows a gathering of the John A Roebling's Sons Company foremen at the Roebling Inn in 1946. (Courtesy Louis Borbi.)

In this 1940s photograph, two boys check their funds before entering the Roebling Cigar Store located on Knickerbocker Avenue between Fourth and Fifth Avenues. The store was owned and operated by Martin Pilger. The cigar store sold candy, newspapers, and tobacco products. It was the prelude to the modern convenience store of today. (Courtesy Louis Borbi.)

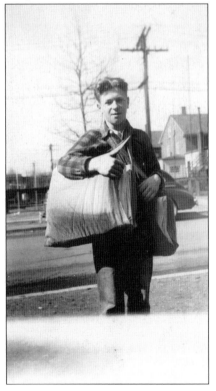

Joseph Varga was a newspaper carrier in 1942 and 1943 and was employed by the Roebling Cigar Store. Notice he is carrying two newspaper bags. Carriers delivered newspapers to homes in the area, including the *Philadelphia Inquirer*, *Philadelphia Bulletin*, *Philadelphia Record*, *Camden Courier*, or *Trenton Times*, depending on the customer's order. Varga delivered 50 newspapers before attending school and 40 newspapers after school. (Courtesy Joseph Varga.)

This January 2, 1940, photograph shows Elizabeth Boros Varga with her son Joseph in their backyard on Fourth Avenue. In the background is the coal bin of the John A. Roebling's Sons Company. The backyard shows snow on the ground, but in the spring, the yard had a garden with kohlrabi, tomatoes, and onions and grapes for Michael Varga to make wine. (Courtesy Joseph Varga.)

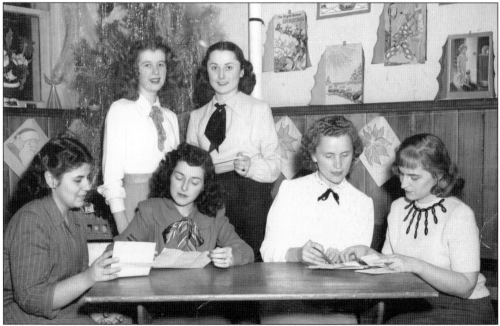

The dance committee reviews its plans at Holy Assumption Hall in 1947. Pictured are, from left to right, (first row) Madelina Lange Sparta, Edith McCord Csik, Ann Rusnak Reed, and Catherine Bago Nyikita; (second row) Mary Arnold Montalto and Mary Simkovich Chanti. (Courtesy Mary Arnold Montalto.)

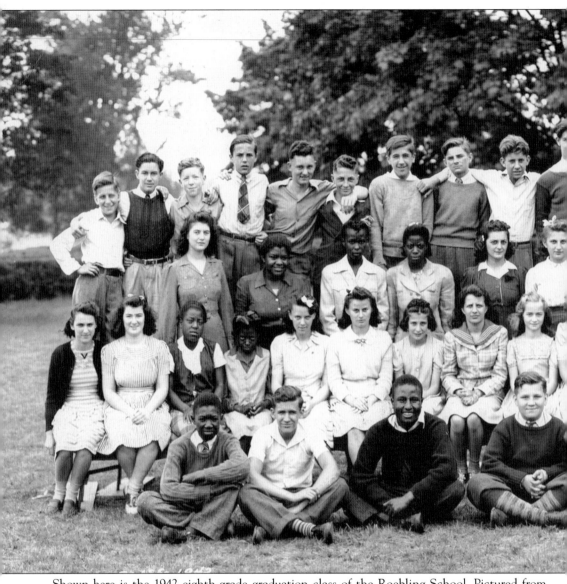

Shown here is the 1942 eighth-grade graduation class of the Roebling School. Pictured from left to right are (first row) William Harris, Floyd Morgan, John Harris, George Yurcisin, Jesse Harris, Paul Anderson, Victor Notigan, and Charlie Harris; (second row) Joyce Hensley, Nancy Cantwell, Catherine Scott, unidentified, Violet Bonner, Ann Burg, Sally Herrity, Mary Nemeth, Vilma Bago, ? Medson, Alma Thomas, Arlene Shafer, Evelyn Timko, Claudine Quistberg, Barbara Trainor, Vivian Jones, Laura Ronyecs, Louise Wainwright, and Jane Regars; (third row)

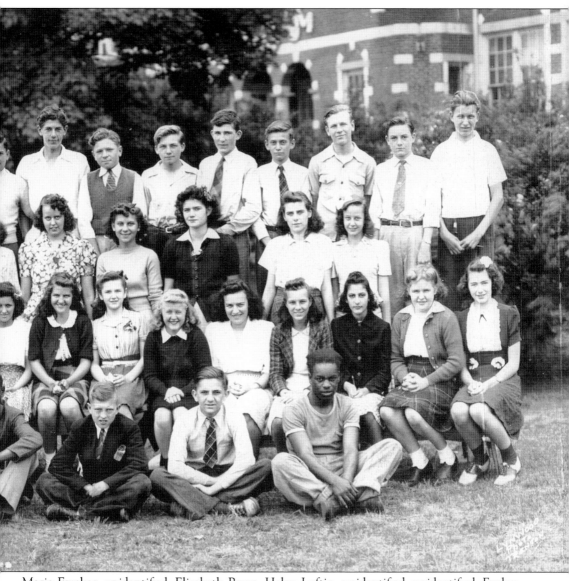

Marie Fazekas, unidentified, Elizabeth Rowe, Helen Loftin, unidentified, unidentified, Evelyn Salaga, Jane Lundin, Irene Csanyi, Katherine Brown, Sarah Challenger, and Vivian Anderson; (fourth row) Joseph Barta, Robert Lee, William Carter, Louis Wargo, John Potpinka, Zoltan Nemeth, George Pendle, Triano Notigan, Richard Blakeslee, Robert Archibald, Sheldon Rush, John Dulo, Joseph Varga, David Csik, Bill Herrity, Roy Wainwright, John Mako, Bill Lee, and Ed Balog. (Courtesy Joseph Varga.)

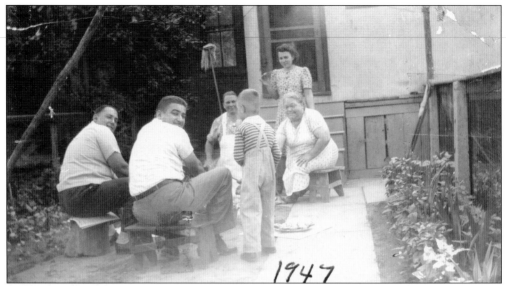

1947

A Roebling delicacy favored by people of eastern European descent is bacon bread, a combination of bacon and its drippings, diced tomatoes, and onions on top of rye bread. Pictured in the foreground, from left to right, are Joe Nyikita, Lou Lung, and Louie Lung. In the background are, from left to right, Mary Nyikita, Juliana Marian, and Julia Lung. All are preparing the bacon bread in the Marians' Third Avenue backyard in July 1947. (Courtesy Maryann Marian.)

This 1948 parade is one of the fun and interesting events that was held in the village of Roebling. Among those enjoying the parade are Jack Quig, "Shorty" Tonne, and "Sluggo" Salaga. (Courtesy Louis Borbi.)

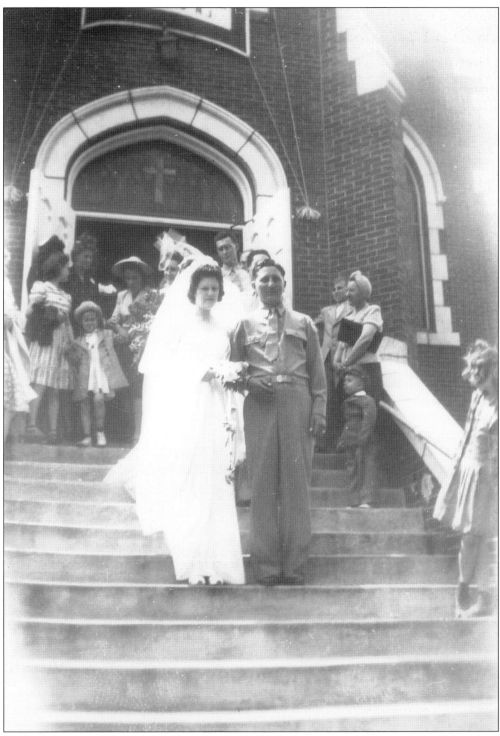

Michael Bugyi and his wife stand on the steps of Holy Assumption Church on the day of their wedding in 1943. Michael Bugyi is wearing his army uniform as the country was involved in World War II. (Courtesy Louis Borbi.)

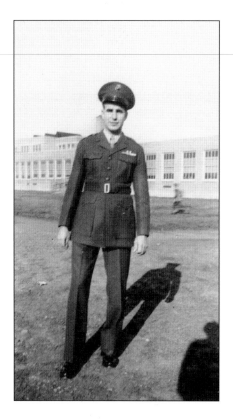

George Magyar was one of the many Roebling residents who enlisted in the armed forces during World War II. This picture was taken in November 1945 while he was on duty. (Courtesy Louis Borbi.)

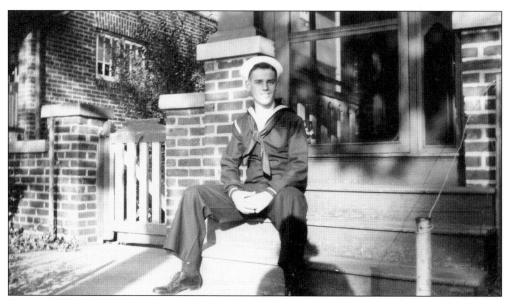

Raymond Philip Hankins, wearing his navy uniform, sits in his parents' home at 18 Eighth Avenue while on leave during World War II. Hankins, known as Philip, was born and raised in the Eighth Avenue home. He retired as a carpenter rigger when the mill closed in 1974 after working there for 37 years. (Courtesy Marion Hankins.)

In this 1944 photograph, Amboy Avenue resident Bill Gyenge is pictured on the left at the submarine net depot in Saipan. The wire for the submarine net is a product of the John A. Roebling's Sons Company. The company also assembled the nets. Pictured to the right in the background is a Roebling wire reel. (Courtesy Bill Gyenge.)

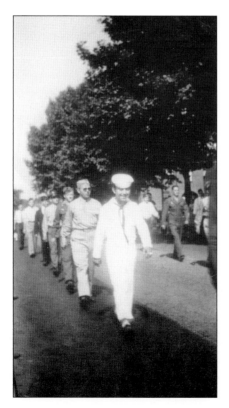

This parade, held in July 1946, honored Roebling residents who served in the armed forces during World War II. Alex "Cremo" Marian, in his navy uniform, leads a line of service members in the parade. (Courtesy Maryann Marian.)

Here is Joseph Bordas with his son Joseph on Alden Avenue in 1949. Young Joseph, age three, is enjoying a bottle of Coca-Cola. Bordas was a business owner for 40 years, specializing as a butcher with an adjoining liquor store. (Courtesy Maryann Bordas Bunnick.)

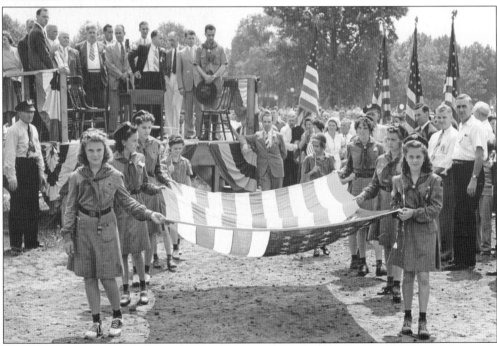

The local Girl Scout troop marches with the American flag during the Fourth of July parade in 1942. The Scout in the front and on the left is Kay McCabe McConaughey (Courtesy Kay Bradshaw.)

Two

ROEBLING IN THE 1950s

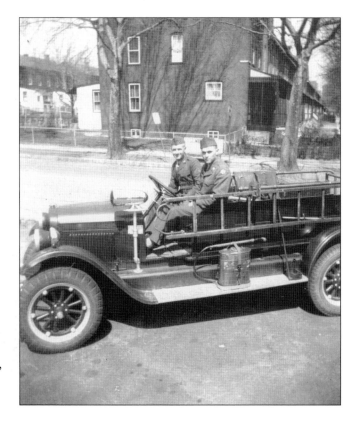

Michael Rusnak (left) and Steve "Fuzzy" Fazekas are pictured at home while on leave from military service. They are sitting in a 1923 Chevrolet truck on Knickerbocker and Second Avenues. The truck was nicknamed "the Beetlebomb." (Courtesy Paul and Loretta M. Varga.)

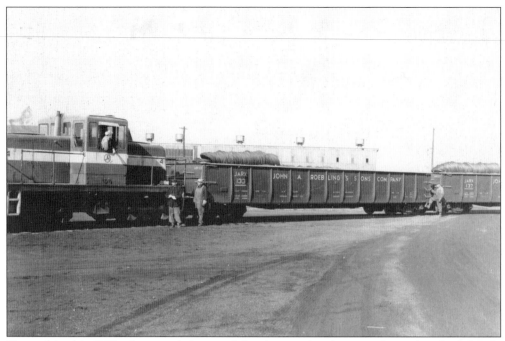

Pictured in this 1950s photograph is one of the three trains that were located at the John A. Roebling's Sons Company site in Roebling. The company's logo is located on the engine, and its name is painted on the cars that held the coiled wire. (Courtesy Louis Borbi.)

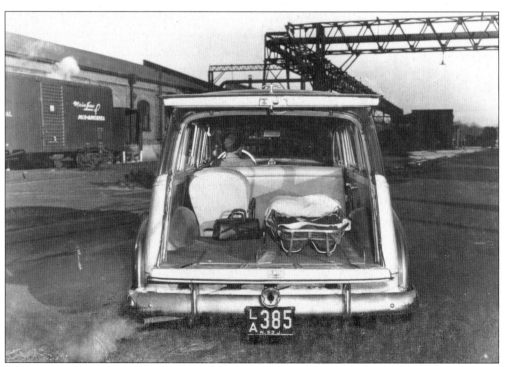

The station wagon ambulance was used for transporting injured workers. When not in use, it was housed in the ambulance garage on Second Avenue. (Courtesy Louis Borbi.)

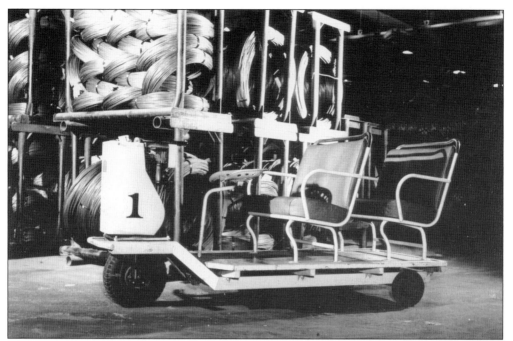

In the bridge shop, galvanized wire is stacked and ready to be shipped to a customer. Pictured is one of the many vehicles used to transport the wire. (Courtesy Louis Borbi.)

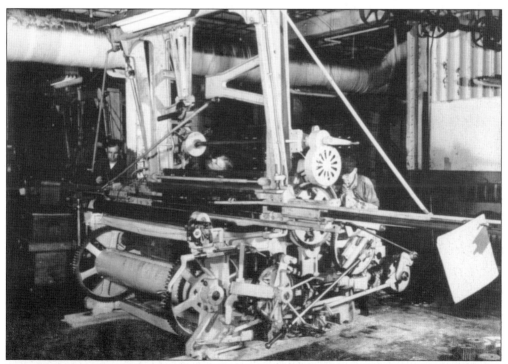

This photograph shows a screening machine in the screen shop in the 1950s. Bronze wire was used to make screens for houses. Three workers can be seen working at this machine. (Courtesy Louis Borbi.)

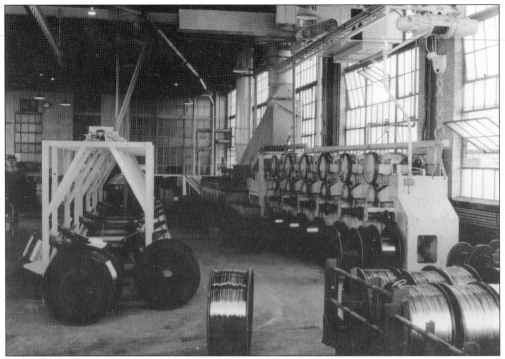

Wire was put onto reels and was then shipped to the mill in Trenton to be made into cable. Pictured here around the 1950s, the patenting shop was located by the galvanized shop on the Roebling site. (Courtesy Louis Borbi.)

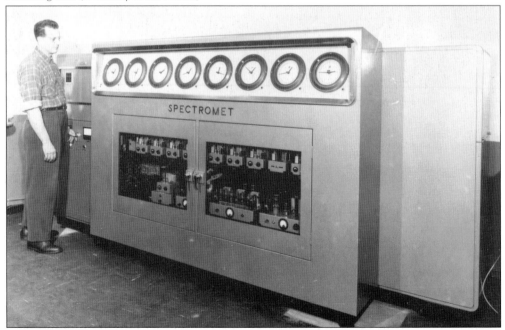

The Spectromet in the steel mill laboratory is a machine that tested a sample of steel. By using this instrument, analyzing the steel for quality took several minutes instead of hours. (Courtesy Louis Borbi.)

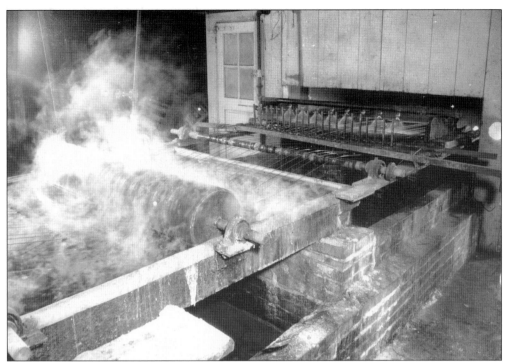

A tire wire rig is pictured in the galvanized shop. Wire was used in making steel belted wires for automobile tires. (Courtesy Louis Borbi.)

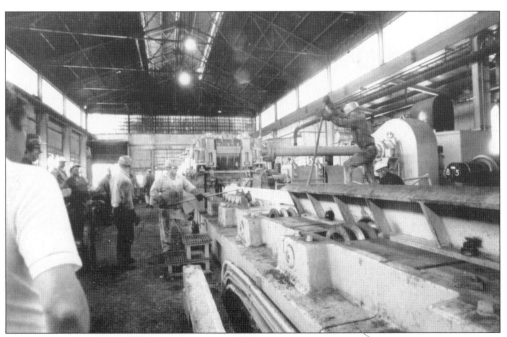

The metal ingots are rolled down to 4-inch billets in the 35-inch mill. Then they move down to the cropping shears where the front and back ends are cut off. From there, the billet proceeds to the 18-inch mill to be rolled down to 2.5-inch billets. (Courtesy Louis Borbi.)

William and Carrie Matlack are sitting on the back porch of their Seventh Avenue home. William was a roll turner at the Roebling mill for 40 years. The couple lived in this home for 58 years. (Courtesy Paul and Loretta M. Varga.)

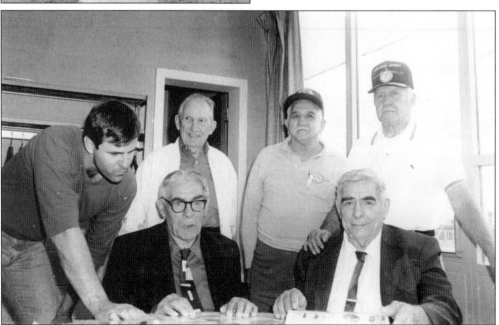

Here bridge workers at the old Union Hall (now the Florence Township Public Library) examine photographs and meet to talk about old times. Seated are Joe Pitko (left) and Jake Pitko. Standing from left to right are unidentified, Steve Turgyan, George Bucs, and Steve "Smitty" Kovacs. (Courtesy Louis Borbi.)

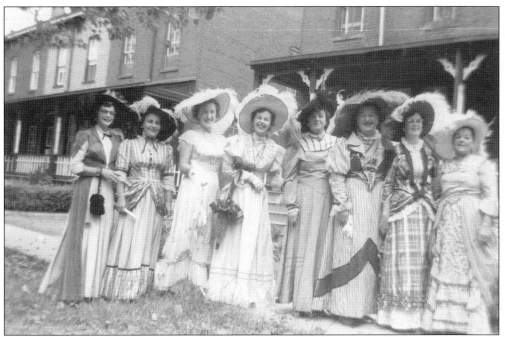

The Roebling Fire Company Ladies Auxiliary is pictured in costumes of the early 1900s for Roebling's 50th anniversary parade in 1955. Some of the auxiliary members pictured are Helen Bordash, Dot Gourovitch, Rose Sofchek, Josephine Szucs, Clare Trainor, and Mary Zahorsky. (Courtesy Helen Bartha Bordash.)

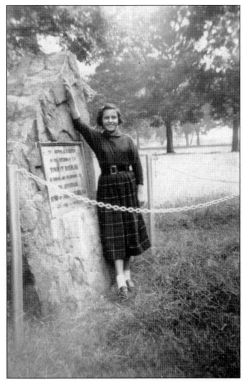

Rose Cardis poses at the Roebling Monument in October 1954. (Courtesy Paul and Loretta M. Varga.)

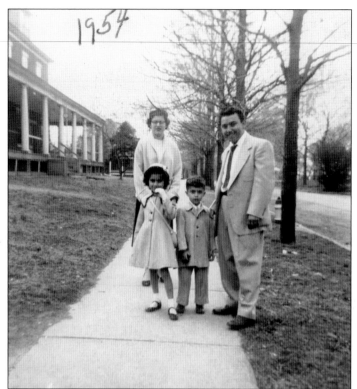

The Marian family walks to Roebling Park after church in April 1954. Josephine and Alex "Cremo" Marian are pictured with seven-year-old JoAnn and five-year-old Alex in front of the Roebling Inn on Riverside Avenue (Courtesy Maryann Marian.)

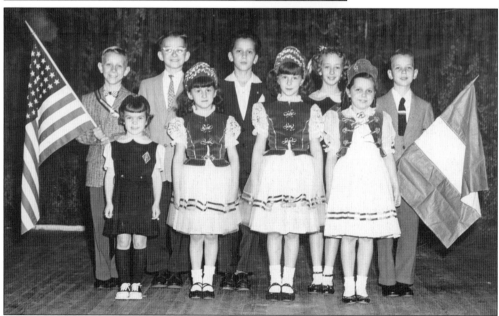

In 1956, during the intermission of the film *Carousel* at the Roebling Auditorium, children raised money for Hungarian refugees. Three of the girls are dressed in traditional Hungarian costume, and speeches were given in Hungarian. Pictured from left to right are (first row) Mary Ellen McGrath, unidentified, unidentified, and Christine Ordog; (second row) Frank Toth, Robert Changery, James Bucs, Rose Talpos, and Paul Ordog. (Courtesy Paul and Janice Ordog.)

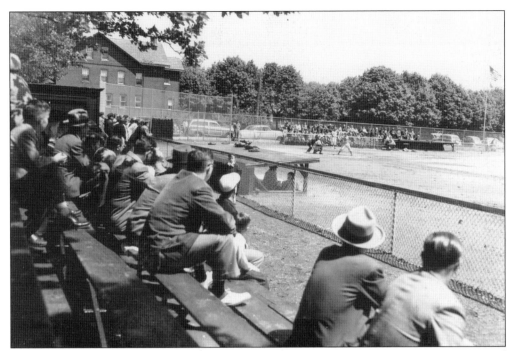

Onlookers watch baseball at the Roebling Ball Park located on Main Street. Spectators enjoyed the games sitting on wooden bleachers. A wire mesh fence replaced the original wood fence. Notice the gentlemen are wearing hats and suit jackets. (Courtesy Louis Borbi.)

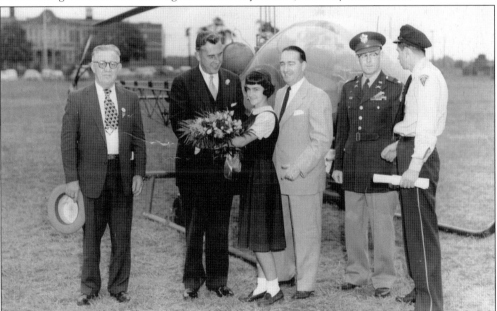

Pictured at the Roebling Ball Park in front of a helicopter in 1955 are, from left to right, Bruce Hubley, Gov. Robert Meyner, 12-year-old Doris "Cookie" Chanti Yaris (who is wearing her Holy Assumption School uniform), Mayor Michael Chanti, unidentified, and Ted Mitre. The Roebling School is in the background. Governor Meyner came to Roebling for the 50th anniversary of the village. (Courtesy Carol Chanti Eckman.)

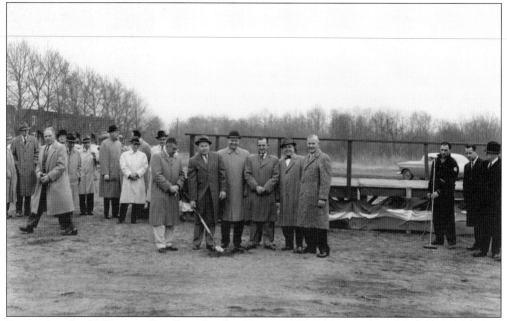

Pictured is the 1950 groundbreaking for the Union Hall on the corner of Knickerbocker and Sixth Avenues. In the center group are, from left to right, Joseph Asszony, Harry "Bucky" Danley, Jerry Dzubryk, Fred Kirkhoffer, John Burzash, and John Bajzath. Buovo "Puddin" Serianni and Joseph Yeager are standing on the right side of the photograph. (Courtesy Louis Borbi.)

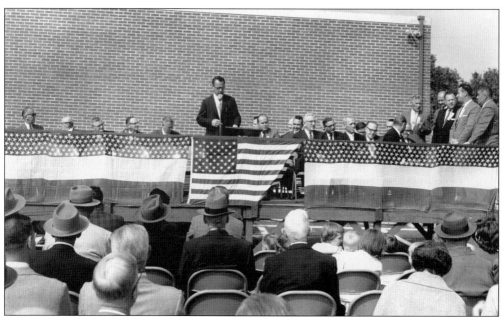

This is the dedication of the new Union Hall by Union Local No. 2110, United Steelworkers of America. Among those pictured are Paul Englund, Earl Conover, Mayor Ken Wilkie, Grover Richman, Joseph Yeager, Harry Danley, Sen. Harrison Williams, United Steelworkers of America president I. W. Abel, Joel Jacobson, Hugh Carcella, George Pellettieri, John Bajzath, Jerry Dzubruk, George Sundin, Ed Ceseretti, and Joseph Asszony. (Courtesy Louis Borbi.)

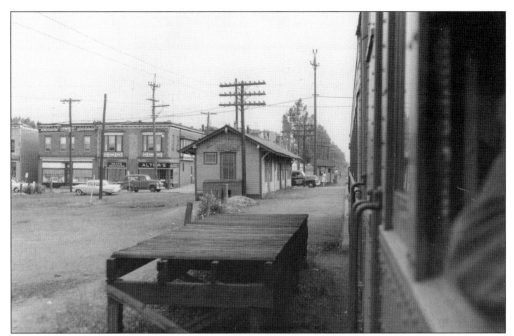

The Roebling train station is pictured here in the 1950s. To the left is Alter's Bar and Grocery Store, where one could purchase meat and groceries. The vehicle underneath the store's sign says John Szucs and Son. The train to the right was the last Camden-to-Trenton passenger train until the New Jersey Transit RiverLine launched in 2004. (Courtesy Louis Borbi.)

Members of St. Mary's Romanian Church are gathered here for a group photograph. Pictured from left to right are (first row) Carol Nyikita, Lois Nyikita, Mary Sinca, and Sandy Paglione; (second row) Peggy Sander, Rose Cardis, Peggy Nyalka, MaryAnn Borbi, Loretta Borbi, and Valerie Bunnick; (third row) Louis Lung, George Lengel, Louis Cardis, Jerry Sandor, Louis Bunnick, Michael Bunnick, and Louis Borbi. (Courtesy Louis Borbi.)

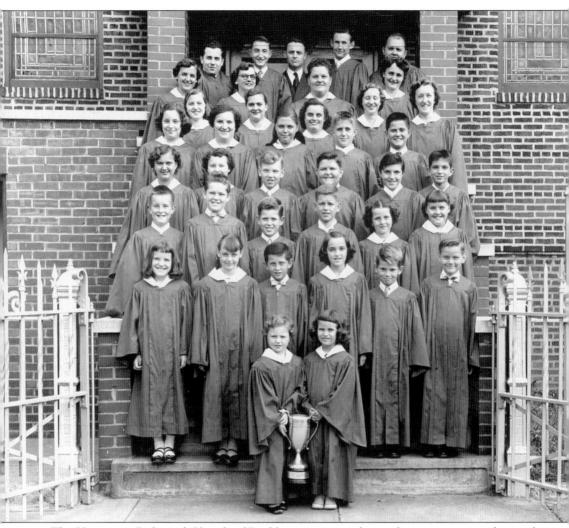

The Hungarian Reformed Church of Roebling participated in a choir competition during the mid-1950s and won the Princeton Cup. Pictured is the choir on the steps of the church. From left to right are (first row) Emily Csogi and Arlene Nagy Primo; (second row) Paula Winner, Marie Boldizar, James Botlinger, Beverly Genasky Tambasco, Paul Papai, and Eddie Stefan; (third row) George Bordash, Roger Csogi, Joseph Papai, Robert Arnold, Margaret Botlinger, and Jean Bajzath Somogyi; (fourth row) Gloria Wargo, Juliann Gonczi, Bert S. Somogyi, Ernie Stefan, James Bartha, and John Genasky; (fifth row) Georgiana Bordash Harkel, Judy Winner, Barbara Boldizar, Robert Keszner, and Frank Todash; (sixth row) Vicki Huber, Julia Wargo, Ann Egyud, Elizabeth Csogi Soltesz Weissberg, and Helen Bartha Bordash; (seventh row) Betty Genasky, Claire Trainor, Betty Stefan, and Mrs. Benko; (eighth row) John Peter, Zolton Gilanyi, Reverend Benko, James Bajzath, and Bertalan Bartha. (Courtesy Hungarian Reformed Church of Roebling.)

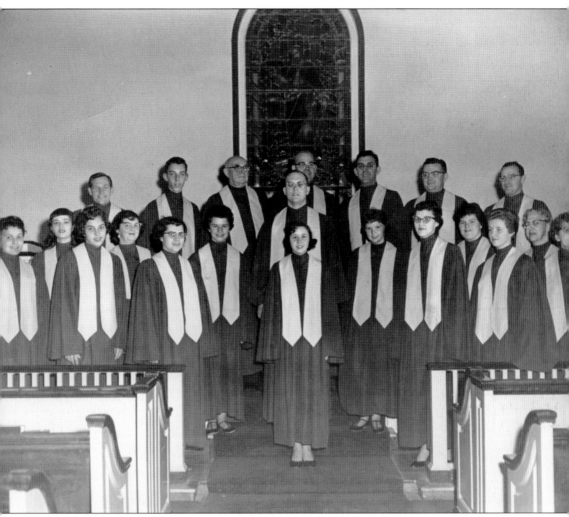

This photograph shows the Trinity United Methodist Church choir in 1957. Pictured, from left to right, are (first row) Jackie Ledger, Adelie Tantum, Phylis Ibach, Marge Schaeffer, Marion McDowall, Beverly McDowall, Carol Allgren, Joyce Long, Catherine Phillips, Carol Schaeffer, Joyce Thomas, Elsie Loring, and Mabel Hubley; (second row) Harry Tonne, Kenneth Ibach Jr., Raymond Danley, Richard Mitten, John Schaeffer, Kenneth E. Ibach, Pastor Donald Phillips, and Alex D. McDowall. (Courtesy Marion McDowall.)

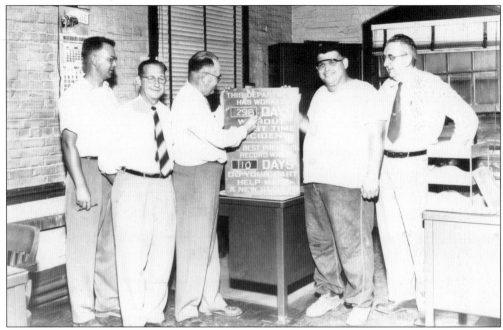

In July 1953, George Pop, Ray Worth, and others from Wire Mill No. 1 change the accident sign that indicates the number of days without an accident. Everyone is pleased the department worked 298 days without an accident. The previous best record was 110 days. The sign encourages workers to "Do Your Part, Help Make a New Record." (Courtesy Louis Borbi.)

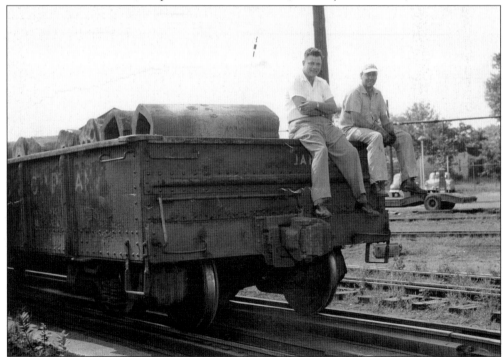

Francis Furham and Milton Taylor take a break in 1954. The men are seated on a train loaded with cast-iron molds for the mill. (Courtesy Louis Borbi.)

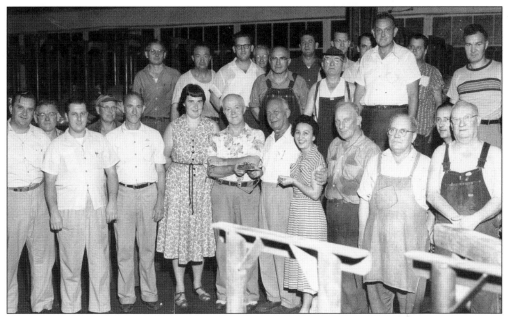

Workers meet for a photograph at the mill in 1954. Pictured are Francis Rakers, Nick Kleiner, John Malmos, Wally Bozarth, Al Schroeder, Esther Turgyan, Jimmy Cantwell, Frank Fisher, Mary Scancella, Jimmy Callahan, Martin Papp, John Turgyan, Mike LeBeda, Tom McKenzie, George Ullman, George Lengel, Marty Stocz, Maury Schnell, Steve Luyber, Harold Pancoast, George Sav, and Steve Gnandt. (Courtesy Louis Borbi.)

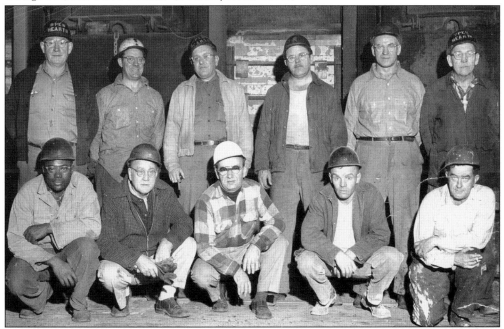

Steelworkers from the Open Hearth pause for a photograph in 1958. Notice that some of the hard hats read "Open Hearth." Pictured from left to right are (first row) Josh Cobb, Bill Marshall, Jule Chanti, Ed Bese, and ? Johnson; (second row) Stan Force, William Norcross, Gardner Bythe, Tony Davis, Bill Pitko, and Julius Burkus. (Courtesy Louis Borbi.)

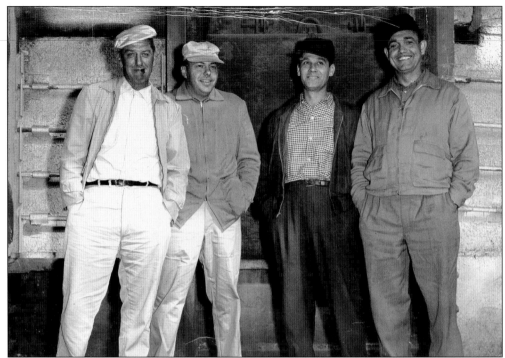

Taking a break at the mill, from left to right are J. Moyer, Louis Boldizar, Bill Molnar, and Charlie Jacob. This photograph was taken in 1959. (Courtesy Louis Borbi.)

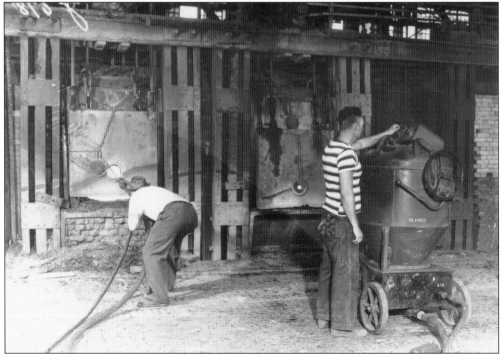

Roebling mill workers are pictured streaming refractory material to the Open Hearth furnace walls in 1952. (Courtesy Louis Borbi.)

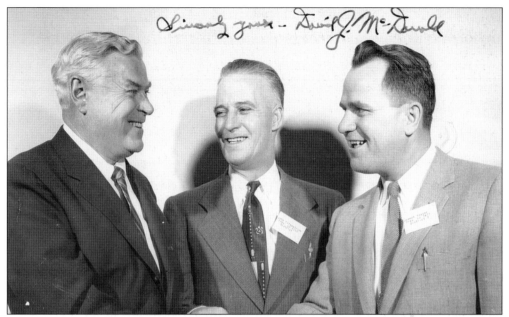

United Steelworkers of America, American Federation of Labor and Congress of Industrial Organizations (AFL-CIO), international president David J. McDonald (left) congratulates John Fitzpatrick (center), president of Local No. 2110, and Joseph Yeager, president of Local No. 3477, for their assistance in negotiating a contract with the Roebling mill workers in 1956. (Courtesy Joseph Yeager)

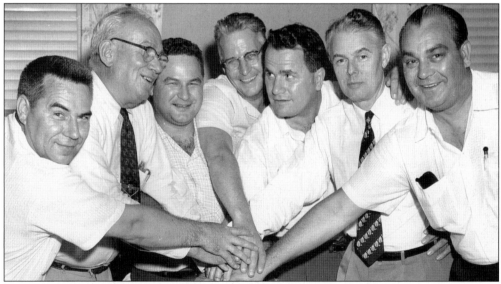

In 1956, a new union contract at the Roebling mill put an end to the longest steel strike in history. Pictured from left to right are John Koches, president of Local No. 3607; Charles "Cap" Jones, director of industrial relations at John A. Roebling's Sons Company; Julius Mate, president of Local No. 2110; John Fitzpatrick, president of Local No. 2110; Joseph Yeager, president of Local No. 3477; William Ridge, industrial relations representative of John A. Roebling's Sons Company; and Charles Kovacs, international staff representative, United Steelworkers of America, AFL-CIO. (Courtesy Joseph Yeager)

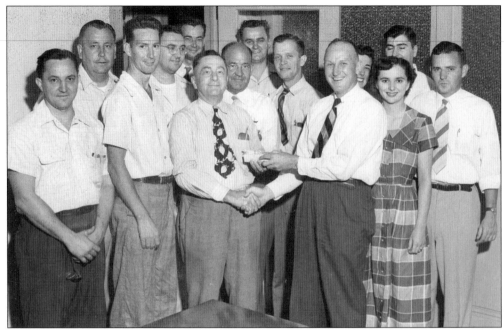

C. R. Wentz is presenting a gift to M. Seifert on July 21, 1954. Pictured from left to right are John Borbi, J. Kokas, Gardner Burkhardt, J. Shevcuk, unidentified, ? Culp, M. Seifert, B. Ritter, Z. Ringhoffer, E. Tantum. C. R. Wentz, E. Catwell, V. Buhan, J. Nemeth, and W. Bradford. (Courtesy Louis Borbi.)

Betty Garbely (left) and Annette Othmer present gifts from people in various departments to Harry Brown Sr., who retired as a clerk in the John A. Roebling's Sons Company storehouse in 1955. (Courtesy Elizabeth Garbely and Louis Borbi.)

The 1955 retirement of John Robotin (center, wearing suit) from the steel mill pit crew is duly noted. Among those pictured are John Potpinka Sr., Pete Litus, John Malic, Eugene Gnandt, Louis Spirida, Willie ?, Julius Burkus, and Bill Molnar from Second Avenue. (Courtesy Helen Potpinka and Louis Borbi.)

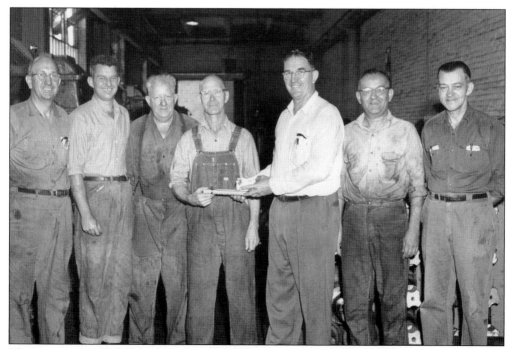

The retirement of Bill Palmer on June 29, 1956, is a joyous occasion for Palmer, who stands with his coworkers. Pictured from left to right are John Leiber, Frank Arnold, William Matlack, Bill Palmer, Bill Miller, Steve Agoes, and Russ Willets. (Courtesy Louis Borbi.)

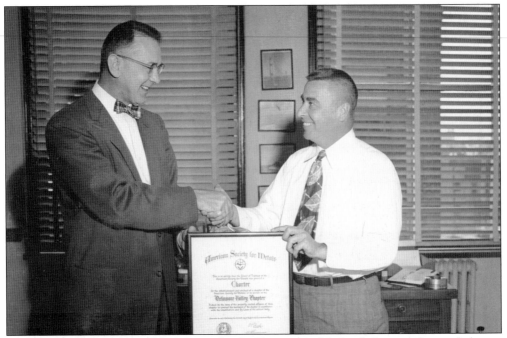

In 1956, Ferdinand W. Roebling III and J. B. Kopec stand behind the certificate of charter membership in the American Society of Metals, now known as ASM International. Kopec was a metallurgical engineer in the hot rolling mills. (Courtesy Louis Borbi.)

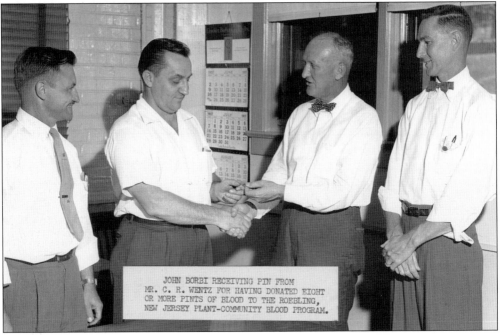

JOHN BORBI RECEIVING PIN FROM MR. C. R. WENTZ FOR HAVING DONATED EIGHT OR MORE PINTS OF BLOOD TO THE ROEBLING, NEW JERSEY PLANT-COMMUNITY BLOOD PROGRAM.

In 1957, John Borbi receives a pin from C. R. Wentz for having donated eight or more pints of blood to the Roebling, New Jersey, Plant–Community Blood Program. Pictured from left to right are Walt Gutermonth, John Borbi, C. R Wentz, and Gardner Burkhardt. (Courtesy Louis Borbi.)

JOHN A. ROEBLING'S SONS COMPANY

TRENTON 2. NEW JERSEY

CHARLES R. TYSON
PRESIDENT

IN REPLY REFER TO

December 8, 1952

Dear Fellow Employee:

Tomorrow you will read in the papers that a contract has been made for the sale of all the manufacturing business, plants and inventories of John A. Roebling's Sons Company, to a wholly owned subsidiary of The Colorado Fuel and Iron Corporation. The contract is subject to various conditions, but we expect the sale to take place on December 31, 1952.

There is nothing to be alarmed about, so don't let it bother you. As a matter of fact I truly believe that the transaction will benefit all of us. We all become members of a large diversified and aggressive steel family—the ninth largest steel producer in America.

I will continue to direct the Company's operations. No change in our personnel, plants or products that would not have otherwise occurred is anticipated. Your pension plans and insurance benefits will continue under the new ownership in accordance with their terms.

Those of you who are members of the several bargaining units will continue to operate under the present contracts.

This change of ownership follows the natural course of events in industrial history. The vast majority of corporations, including The Colorado Fuel and Iron Corporation, are owned by thousands of people. Their stocks are on the open market and can be bought and sold by the owners as they choose. Many of the larger steel companies of today grew out of a number of smaller companies that were "family owned" or "closely held" such as we. The disadvantage of closely held stock by relatively few people is that it cannot be easily disposed of. It has no ready market and is, therefore, not a liquid asset. With the extremely high inheritance taxes of today (Federal and State) any estate with a large portion of non-liquid stock presents a most difficult tax problem. This is one reason (and a big one) why this action will be taken.

The transfer of Roebling ownership was inevitable at some time and we believe that the best solution for all concerned has been reached.

The present owners of the John A. Roebling's Sons Company wish to express to you their appreciation of your loyal services to their organization. I earnestly request and urge your continued cooperation and support under our new ownership.

Sincerely yours,

Charles R. Tyson

President

Charles Roebling Tyson, president of John A. Roebling's Sons Company and grandson of Charles G. Roebling, sent this letter informing employees that the company was being sold. The letter is dated December 8, 1952. The sale of the company to Colorado Fuel and Iron Corporation took place on December 31, 1952. (Courtesy Louis Borbi.)

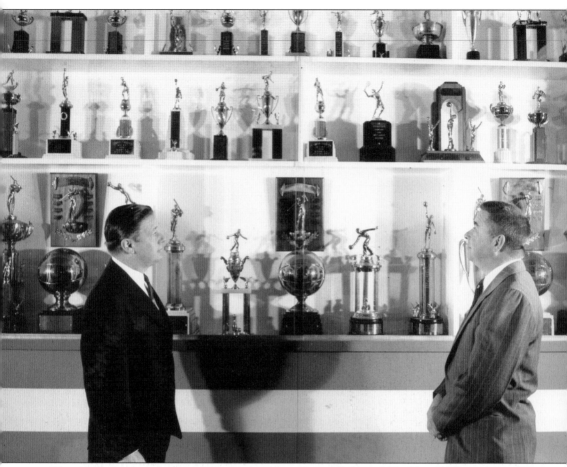

This 1957 photograph shows Charles Roebling Tyson (left) and Ferdinand W. Roebling III in the main office of John A. Roebling's Sons Company in Trenton. Tyson was president of the company until 1952 and then an executive vice president of its successor, Colorado Fuel and Iron Corporation, until 1959. Roebling was senior vice president and chief of engineering for John A. Roebling's Sons Company and then senior vice president of engineering for Colorado Fuel and Iron until 1965. (Courtesy Louis Borbi.)

Three

THE 1960S AND THE 1970S

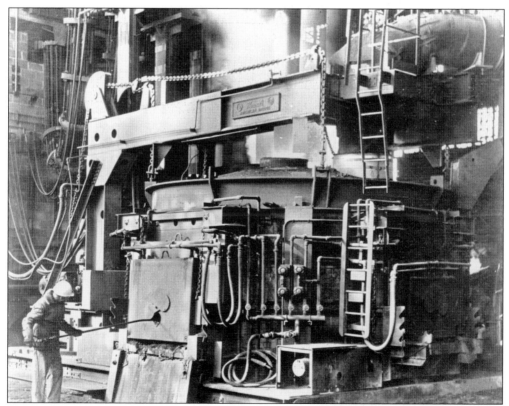

A new electric furnace is in operation at the steel mill in the 1960s. The worker in the lower left corner is extracting a sample of steel to be checked in the Spectromet. (Courtesy Louis Borbi.)

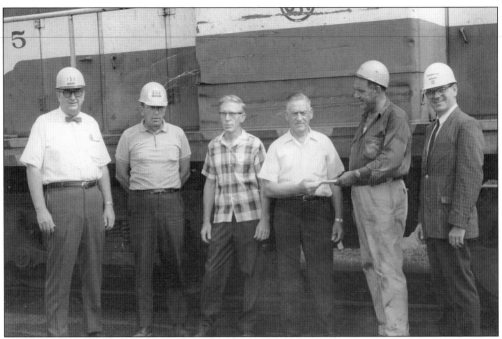

Pictured from left to right are Ed Burkhardt, Jim Denyon, Bobby Nelson, Ray Nelson, Stanley Eirikis, and unidentified in front of a John A. Roebling's Sons Company train in 1967. (Courtesy Louis Borbi.)

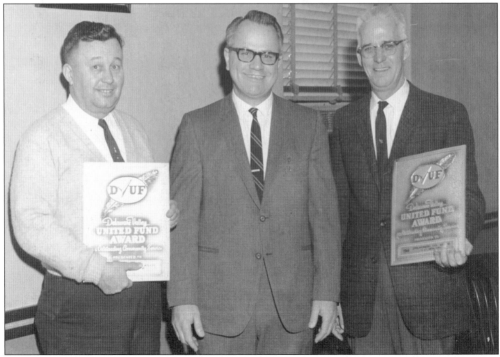

John Ferenci, Joseph Yeager, and John Fitzpatrick are pictured with the Delaware Valley United Fund Awards for Outstanding Community Service on May 10, 1971. (Courtesy Louis Borbi.)

Philip "Dutchie" Lynch is pictured in the 1970s at the controls in the tower of the 35-inch mill. The controls performed 11 tasks to bring the 2,800-pound ingot through 11-13-16 passes to make whatever size bar was needed. (Courtesy Philip "Dutchie" Lynch.)

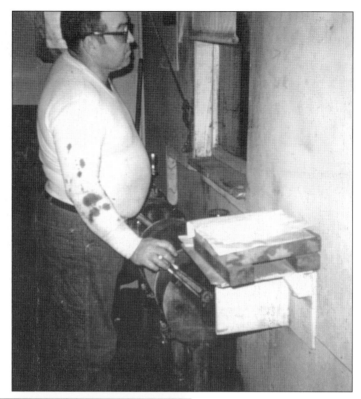

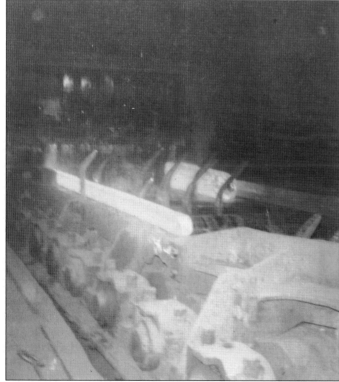

The raw ingot on the right side of the picture is going through the first pass. The ingot turns into a 4-foot-by-4-foot steel billet that is 30 feet long, similar to the billet pictured in the foreground. This billet is in the last stage of completion in the Blooming Mill. (Courtesy Philip "Dutchie" Lynch.)

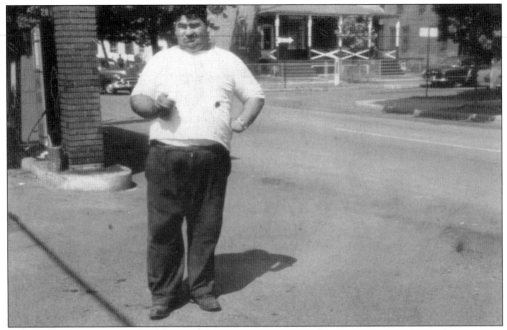

Steve "Jabo" Bucs stands in from of his gas station, located on Hornberger and Fourth Avenues. The gas station became a place where young people congregated and discussed the events of Roebling. One of Bucs's siblings was Sr. Mary Germaine, F.D.C. Wherever she served as a Sister of Divine Charity, his generosity followed. (Courtesy Louis Borbi.)

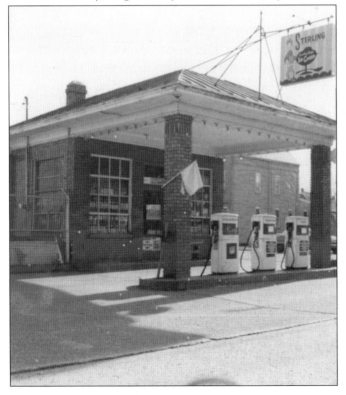

The energy crisis affected the village of Roebling in the 1970s. The white flag meant "no gas" at Jabo's Gas Station on Hornberger and Fourth Avenues in 1974. The gas station was a popular spot for Roebling residents. (Courtesy Louis Borbi.)

George Bucs stands inside Jabo's Gas Station in December 1975. It sold candy, snacks, and automotive items as well as gasoline. In addition, it had a pinball machine that was very popular. (Courtesy Louis Borbi.)

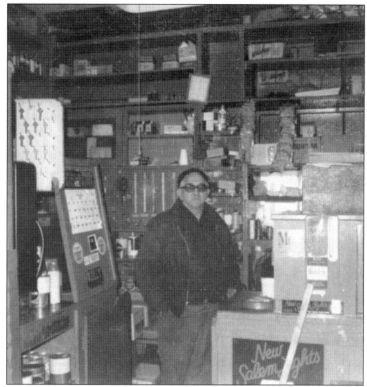

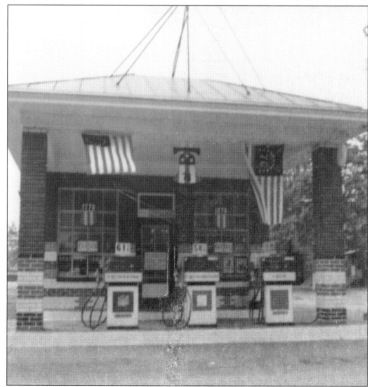

Jabo's Gas Station is decorated for the bicentennial parade on July 2, 1976. Notice the price of gasoline is 61¢ and 58¢ per gallon. The brick columns and the front of the building were painted red, white, and blue in a display of patriotic pride. (Courtesy Louis Borbi.)

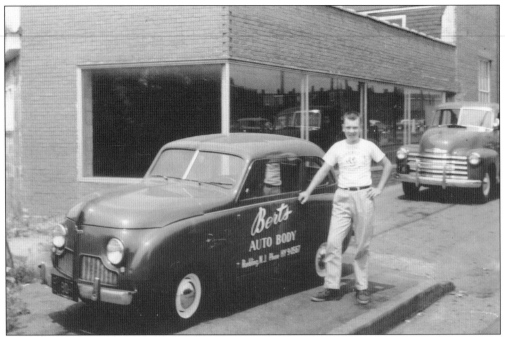

During the summer of 1960, Bert S. Somogyi stands with his first car, a 1948 Crosley. Somogyi is pictured in front of his father's auto body shop, located on Hornberger Avenue. The shop was in business from 1948 until his father's retirement in 1979. (Courtesy Bert S. Somogyi.)

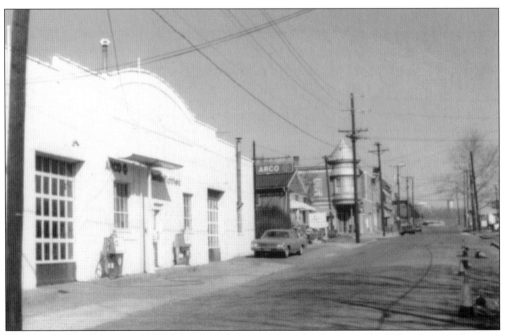

The day before Easter in 1977 shows two businesses at the lower end of Hornberger Avenue. Bert's Auto Body is in the foreground and Lamson's Flower Shop is just to the right. On the steps of the flower shop, there are Easter flowers for sale. Bert's Auto Body was sold and eventually demolished. The flower shop is now a convenience store. (Courtesy Louis Borbi.)

Mansion House Apartments, located on Fourth Avenue, is pictured here in 1974. This was an original Roebling building known as Boarding House No. 1. It once housed the doctor's office, hospital, booster club, and post office. The building was converted into apartments and the columns and overhang were added to the facade of the building. (Courtesy Louis Borbi.)

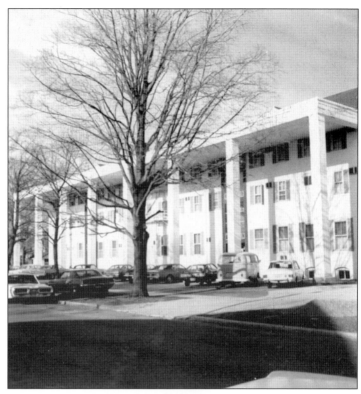

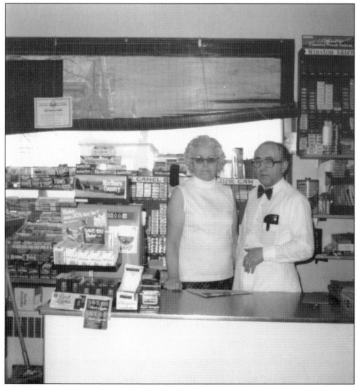

John Korinko and Anna Simkovich Korinko pose for a photograph on the day of their retirement in 1979. They worked at their family-run store, known as Korinko's for 27 years. Delicatessen foods and household items were sold in the store located on Knickerbocker Avenue (now Hornberger Avenue) between Fourth and Fifth Avenues. Hoagies, sandwiches, and salads were made fresh daily and sold to customers. (Courtesy Louis Borbi.)

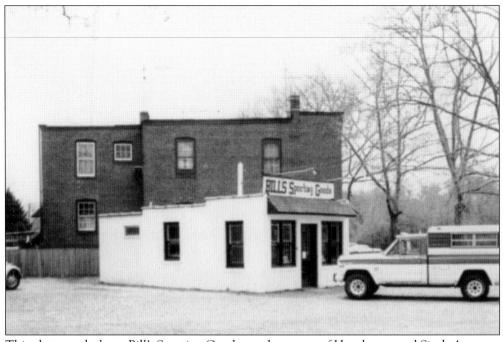

This photograph shows Bill's Sporting Goods, on the corner of Hornberger and Sixth Avenues, in May 1978. This building was previously Phil's Steak House, Matlack's Flower Shop, Lamson's Florist, and Eichinger's Bakery. (Courtesy Louis Borbi.)

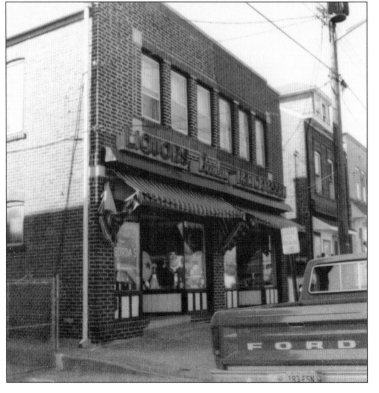

Bordas' Liquors and Delicatessen store on Alden Avenue is shown in this 1977 photograph. This family-run store was a 40-year-old business in Roebling where patrons could purchase meats, groceries, and spirits. (Courtesy Louis Borbi.)

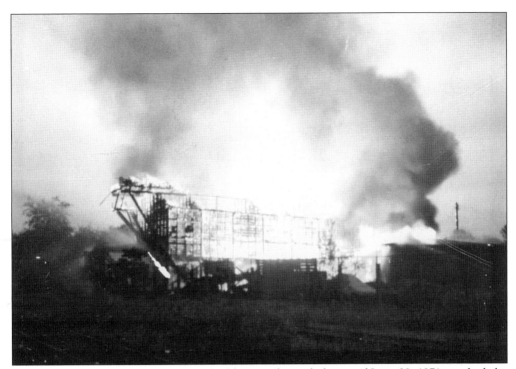

The burning of Pinto's Coal Storage building in the early hours of June 29, 1971, marked the demise of an original Roebling structure. This silo stored the coal for the heating of village homes in the early years of Roebling. (Courtesy Joseph Pinto.)

The Willets-Hogan-Tonne American Legion Post No. 39 suffered a devastating loss on January 1, 1969. Fire broke out in the building on a frigid winter day as volunteer firefighters battled the blaze. This building, located on Fourth Avenue, was an original Roebling structure, formerly known as Boarding House No. 2, and was housing for John A. Roebling's Sons Company workers. (Courtesy Louis Borbi.)

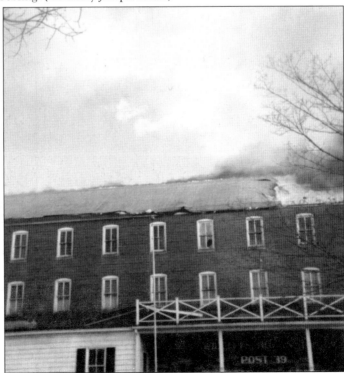

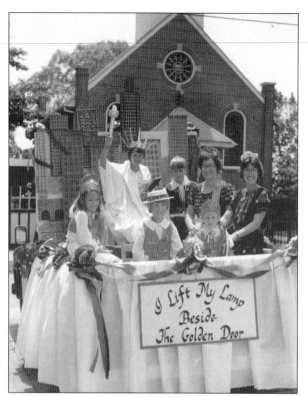

"I Lift My Lamp Beside the Golden Door" are the words from the Statue of Liberty welcoming immigrants to the United States from around the world. Jean Bajzath Somogyi is dressed as Miss Liberty. Also pictured are, from left to right, Sandra Somogyi, Christopher Harkel, James Bajzath, Georgiana Bordash Harkel, Jennifer Bajzath Dennis, and Miriam Bajzath, who are dressed in traditional Hungarian garb in the 1976 bicentennial parade (Courtesy Hungarian Reformed Church of Roebling.)

The James Marshall Band is pictured marching down Third Avenue during a Fourth of July parade in the 1960s. (Courtesy Louis Borbi.)

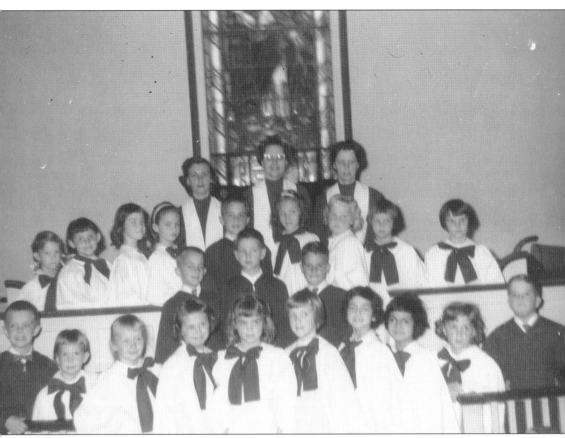

Pictured is the Trinity United Methodist Church choir in 1961. They are, from left to right, (first row) Lee Benger, Leslie Nolan, unidentified, Patty Groze, unidentified, Janet Smith, Helena Mason, Rose Mason, Connie Hill, and Dana Paykos; (second row) Gregory Flynn, unidentified, and Mark Flynn; (third row) Jeanette Nolan, unidentified, Susan Gaul, Gail McDowall, James Flynn, Janice Oblinger, unidentified, Kay Ellen Oblinger, and unidentified; (fourth row) organist Dolores Kirkan, choir mother Marion McDowall, and choir director Jeane Nolan. (Courtesy Marion McDowall.)

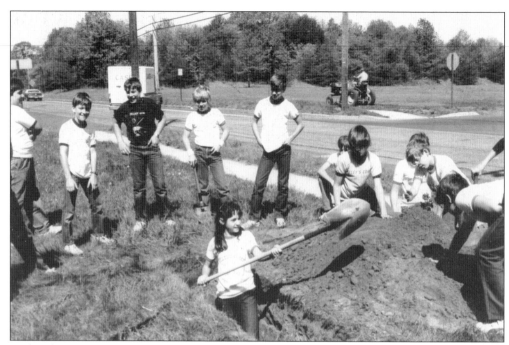

In the photograph above, Rochelle Yanchysyn digs a hole for the Halley's Comet time capsule as Roebling Elementary sixth-grade students wait their turn to dig. The photograph below shows the time capsule, which includes information about Halley's Comet and world and local events, as well as artifacts supplied by the students. This time capsule was buried in 1986 and is to be opened in 2061 when Halley's Comet is predicted to return. (Courtesy Louis Borbi.)

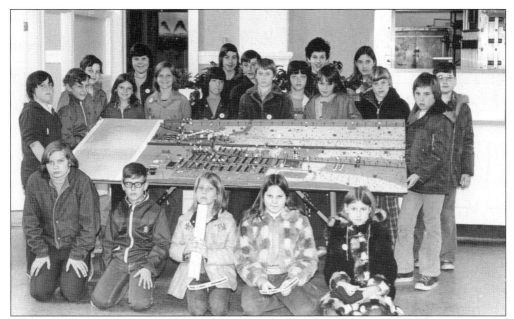

In 1975, Louis Borbi's sixth-grade class created a model of the village of Roebling using clay, balsa wood, and sawdust. Pictured from left to right are (first row) Ken McIntyre, Tom Anderson, Karen Smith, Debbie Wright, and Lisa Fiscor; (second row) Jim Chanti, David Gowie, Dan Hay, Marie Murisan, Charlotte Kohfeldt, Veronica Iszak, Ricky Navarro, David Ridgeway. Steven Horvath, Ike Vannel, Mark Sparta, Michelle Seidl, David Martosofski, Carol Lupex, John Perry, Jim McCue, and Pat Currie. Class members not pictured are Arthur Mullenax and Diane Ackerman. (Courtesy Louis Borbi.)

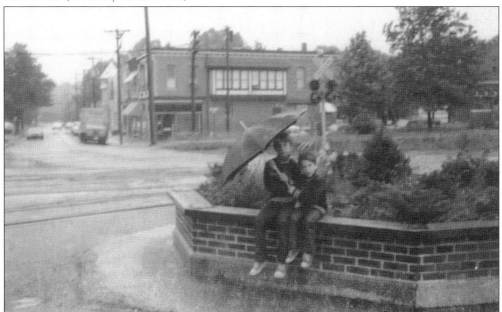

John David Borbi (left) and Patrick Borbi sit under an umbrella waiting for their father, John Borbi, to leave the mill on the last day of operations, June 29, 1974. In the background is Alden Avenue. (Courtesy Louis Borbi.)

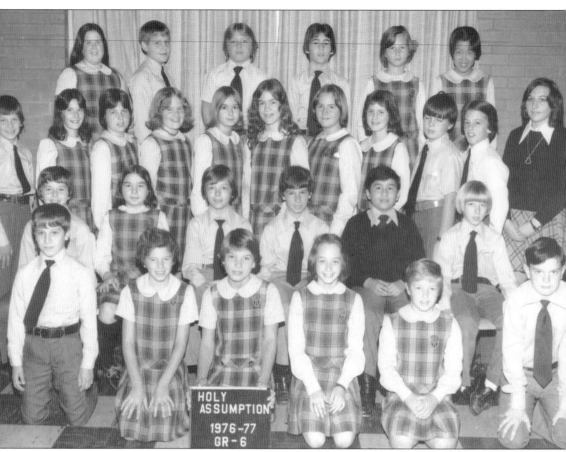

This photograph shows the sixth-grade class of Holy Assumption School from the 1976–1977 school year. From left to right are (first row) Frank Angelini, Regina Bunnick, Sherri Soltes, Debbie Bottinger, Kim Kotch, and William Hickey; (second row) Paul Lewandowski, Catherine Reca, Ed Seger, James Petrucelli, Diego Reyes, and Ted Lovenduski; (third row) Christopher Jakim, Erika Szalai, Monica Rockhill, Brooke Meyers, Janice Hatalovsky, Barbara Allen, Judee Ross, Laura Hicks, Joseph Csik, John Borbi, and teacher Michelle Varga Scott; (fourth row) Katie Evrard, Stephen Fazekas, Vincent Stefanic Stevens, Michael Korinko, Joyce Challender, and Janet Lee. (Courtesy Michelle Varga Scott.)

This is the home of the Sfanta Maria Roumanian Society Club, located on Norman Avenue in 1975. Members would meet and socialize about village events. In the early days of the village, each ethnic group had its own social club. There were Hungarian, Russian, and Slovak clubs in addition to the Romanian club. The Slovak club is still in existence. (Courtesy Louis Borbi.)

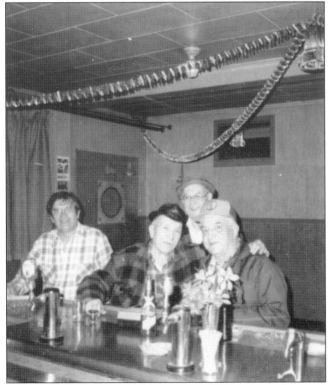

Pictured from left to right are Leon Czartorski, Al Kish, George Fazekas, and John Borbi meeting at the Romanian club on Norman Avenue in 1978. (Courtesy Louis Borbi.)

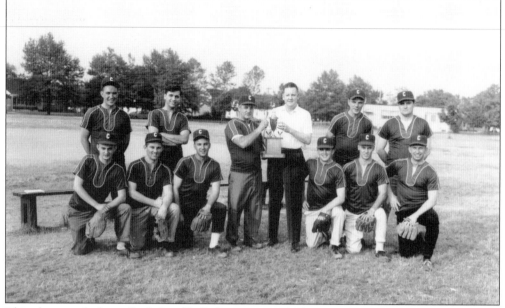

This photograph shows Corky's softball champions with their trophy in 1960. Pictured from left to right are (first row) Louis Borbi, Bill McDade, Alex Varava, Pete Litus, Corky O'Donnell, John Borbi, Larry Reed, and John Jakim; (second row) Tom Morrisey, Joe Garbely, Dick Muchowski, and Joe Meszaros. The team's sponsor, Corky's Bar, was located on Hornberger Avenue near Amboy Avenue. (Courtesy Louis Borbi.)

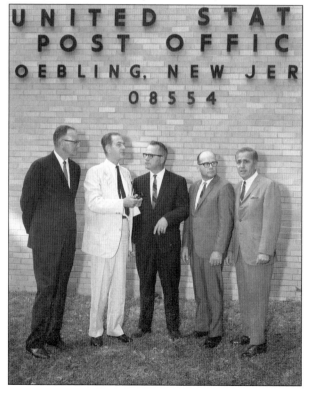

At its dedication in 1966, in front of the Roebling Post Office on the Main Street Circle stand, from left to right, Florence Township mayor H. Kenneth Wilkie, Sen. Clifford Case, Joseph Yeager, Harry Danley, and Pete Rossi. (Courtesy Louis Borbi.)

Four

THE 1980S, 1990S, AND BEYOND

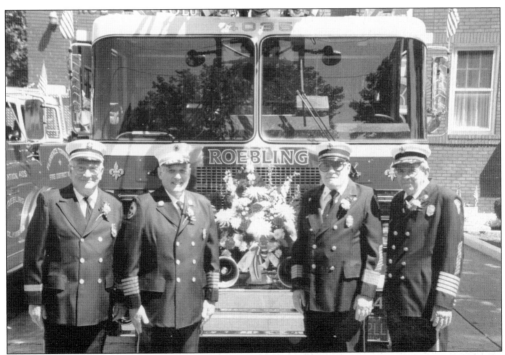

From left to right, Steve "Fuzzy" Fazekas, Buovo "Puddin" Serianni, Lou Spirida, and Ted Mitre Sr. pose in front of a Roebling fire truck on Main Street in 1997. Mitre was the grand marshal and all four men were honored for their many years of service to the Roebling Fire Company. (Courtesy Steve "Fuzzy" Fazekas.)

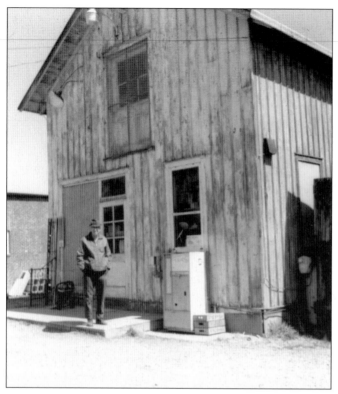

Pinto's has been in business since 1947. This store is packed with items one would need to make any repair in one's home or yard or to automobile. Joe Pinto's unique organizational system allows him to assist all customers in a speedy manner. The photograph on the left shows Joe Pinto in front of his store in 1977. The photograph below shows Pinto happily assisting a customer in 1988.

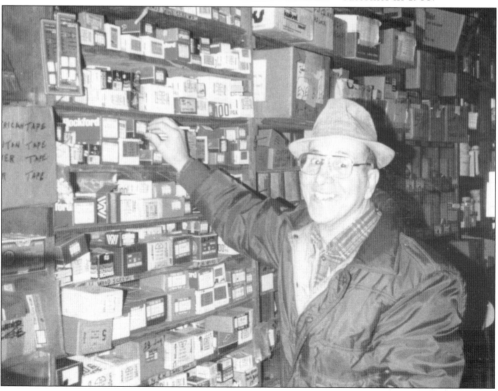

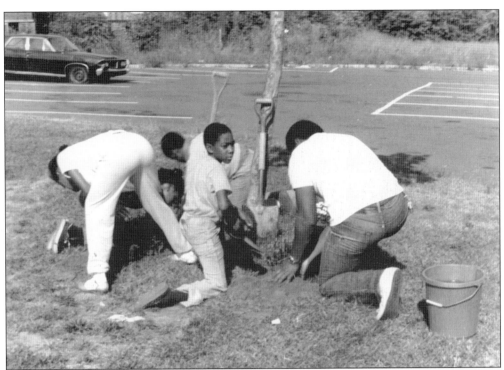

The photograph above shows a tree being planted on Railroad Avenue in 1981. The children are very eager to assist with the planting. The photograph below shows helpers, enlisted by the Roebling Historical Society, painting metal drums to be used for trash disposal at the Railroad Avenue playground. (Courtesy Paul and Loretta M. Varga.)

The Roebling Garden Club sponsored a scarecrow contest at the Main Street Circle for many years. All residents were encouraged to participate and prizes were awarded. (Courtesy Paul and Loretta M. Varga.)

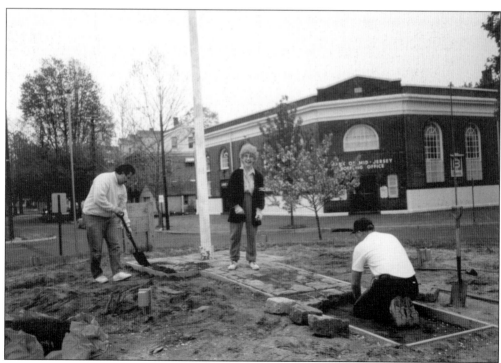

Roebling Garden Club members, from left to right, Lou Bontya, Gabriella Pensyl, and Harry Robinson Jr. work at the Main Street Circle in 1994. (Courtesy Paul and Loretta M. Varga.)

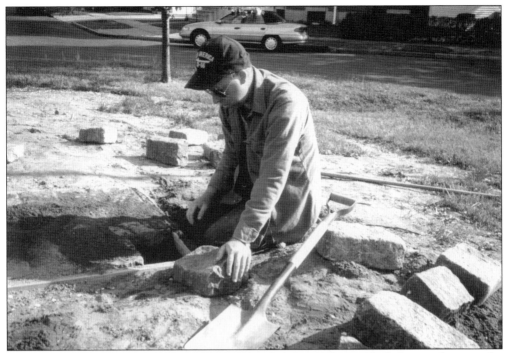

Harry Robinson Jr. works at the Main Street Circle laying Belgium block for a pathway to the flagpole in the center of the circle in 1994. (Courtesy Paul and Loretta M. Varga.)

From left to right, Paul Crammer, George Lengel, Louis Borbi, Richard Sweeney, and Richard (Dick) Sweeney take a break from their project in 1995. They are working on the base for the main cable to be placed on permanent display in front of the Florence Township Public Library. Behind the main cable, a time capsule was buried from the 75th anniversary of the village of Roebling. (Courtesy Louis Borbi.)

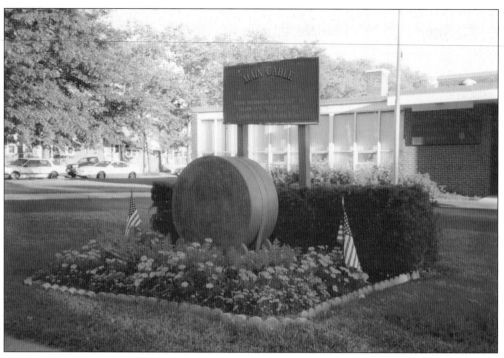

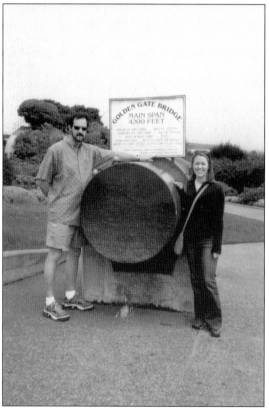

The photograph above shows a cross section of the main cable that is on permanent display in front of the Florence Township Public Library on Hornberger Avenue. The main cable has 27,572 wires and is painted international orange, which is the color of the Golden Gate Bridge. The sign above includes the names of famous Roebling bridges. The logo was designed by then sixth-grade Holy Assumption School student Christine Sweeney Skinner. The photograph on the left shows the sister main cable located in San Francisco on the grounds near the Golden Gate Bridge. The sign above it gives statistics about the bridge. The bottom entry reads, "Cable Contractor John A Roebling's Sons Company, Trenton and Roebling, NJ." The Golden Gate Bridge cables were the largest ever built, using 80,000 miles of cable and 271 tons of wire. This photograph shows Michael M. Scott and Megan Scott Verzi at the San Francisco main cable in August 2003. (Courtesy Michelle Varga Scott.)

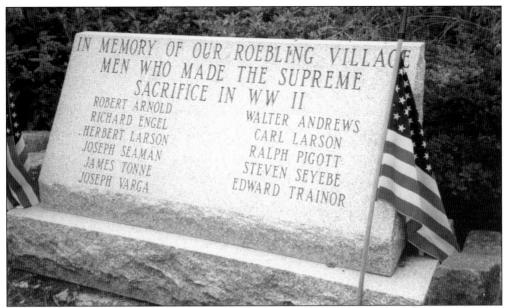

In the 1990s, a monument listing the men who made the supreme sacrifice during World War II was placed at the Main Street Circle. Thomas and Shirley Pierson purchased the monument to insure the Roebling boys would not be forgotten. The names listed are Robert Arnold, Richard Engel, Herbert Larson, Joseph Seaman, James Tonne, Joseph Varga, Walter Andrews, Carl Larson, Ralph Pigott, Steven Seyebe, and Edward Trainor. (Courtesy Paul and Loretta M. Varga.)

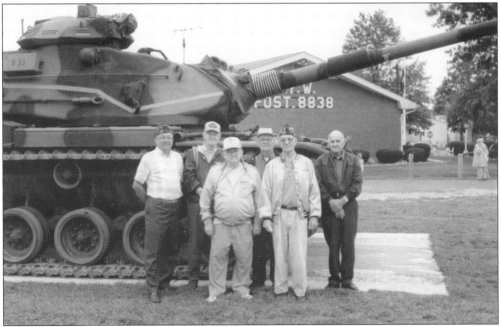

Veterans of Foreign Wars Post No. 8838 acquired a World War II tank to display on the its grounds. From left to right, members Steve Mognancki, Tom Gorse, Philip "Dutchie" Lynch, Frank Miller, Jack Berger, and Raymond Jones pose with the tank in 1992. (Courtesy Philip "Dutchie" Lynch.)

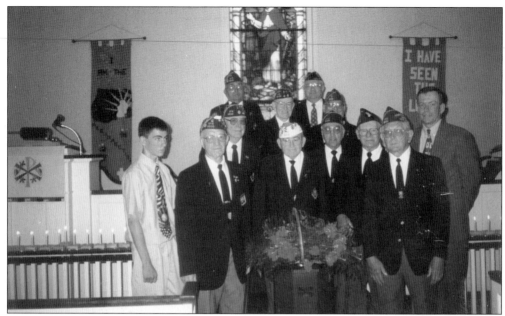

In this photograph from about 2000, veterans gather in the Trinity United Methodist Church after a ceremony. Pictured from left to right are (first row) John Porter, who played the trumpet, John (Jack) Berger, Philip "Dutchie" Lynch, Ernie Del Casino, Frank Miller, Bob Shaler, and Donald Porter; (second row) Jack Foster, Tom Gorse, and Dick Glass; (third row) Steve Mognancki and Jack Lord. (Courtesy Marian McDowall.)

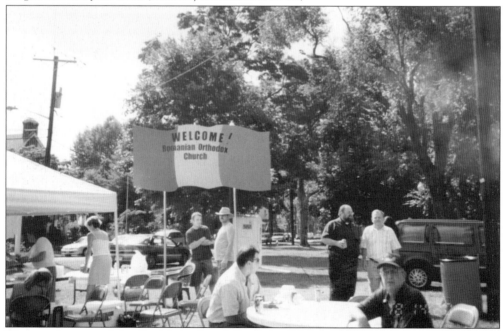

The parishioners of the St. Michael and St. Gabriel Romanian Orthodox Church have a welcome sign at the booth in Roebling Park, located on Riverside Avenue. They sold stuffed cabbage, pork with sauerkraut, sausage, and well-seasoned *mititei*. On the right is priest Vasilescu Eugen talking with church member Steve Voj. (Courtesy Mr. and Mrs. Marius Budiu.)

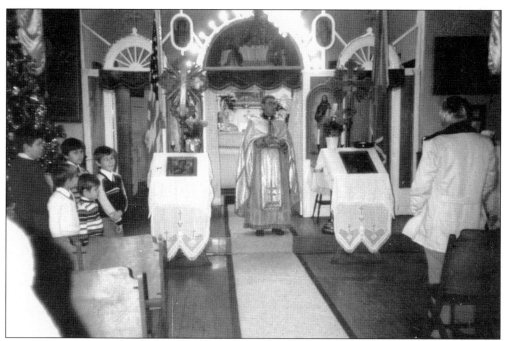

This photograph shows a Christmas service at St. Michael and St. Gabriel Romanian Orthodox Church, located on Hamilton Avenue and Sixth Street. The priest who conducted the service was Vasilescu Eugen. (Courtesy Mr. and Mrs. Marius Budiu.)

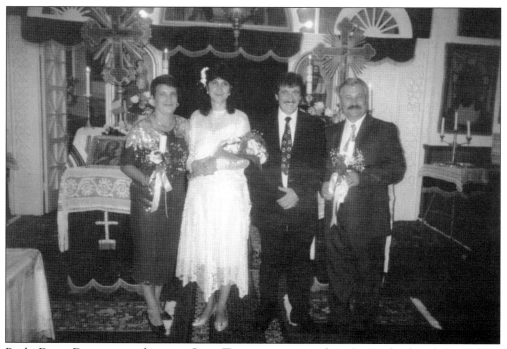

Bride Dana Dragomir and groom Savu Turcu were married in St. Michael and St. Gabriel Romanian Orthodox Church. The matron of honor was Maria Luca Cris, and the best man was Octavian Luca Cris. (Courtesy Mr. and Mrs. Marius Budiu)

Members celebrate the 90th year of the Hungarian Reformed Church of Roebling. Pictured from left to right are (first row) Miriam Bajzath, James Bajzath, Marla Bajzath with son Brandon Bajzath, Elizabeth Bajzath, Margaret Abraham, Helen Coffee, Helen Bordash, Kayla Habeck, and Mike Habeck holding daughter Emily Habeck; (second row) Jimmy Bajzath, Alexander Bajzath, Jennifer Bajzath Dennis with Kyle Dennis, Erlene Hope, Rev. Garey Hope, Roberta Frantz, Rev. Horace Frantz, Georgiana Bordash Harkel, and Josh Scassero; (third row) Irene Szabo, Rose Bartha, Ethel Palmieri, and Goldie Szinyeri; (fourth row) Charles Weissberg, Elizabeth Soltesz Weiss Berg, Rev. Dan Cline, Sandy Todash, and Frank Todash; (fifth row) Michelle Varga Scott, Melanie Soltesz Pielacha, Corinne Varga, Joseph Varga, Debbie Storer, and Ed Storer; (sixth row) Matthew Scott, Joseph B. Varga, Bertha Bartha, Melissa D'Annunzio, and Ted Joseph D'Annunzio; (seventh row) Christian Varga, Joseph Bartha, Nancy D'Annunzio, and Ted D'Annunzio. (Courtesy Hungarian Reformed Church of Roebling.)

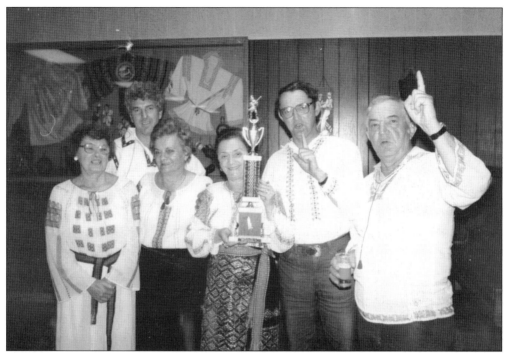

Members of St. Mary's Romanian Church celebrate the second-place finish for their float in the annual Patriotic Day parade in 1980. In the photograph above, church members are celebrating. Pictured from left to right are Betty Bunnick, Michael Bunnick, Loretta Borbi, Yolanda Borota, Louis Borbi, and John Borbi Sr. In the photograph below, Michael Bunnick, Maryann Bordas Bunnick, Madeline Rebeles, Louis Borbi, John Lupex, Julia Foulks, Louis Bunnick, and Stu Foulks are pictured in front of the award-winning float. (Courtesy Louis Borbi.)

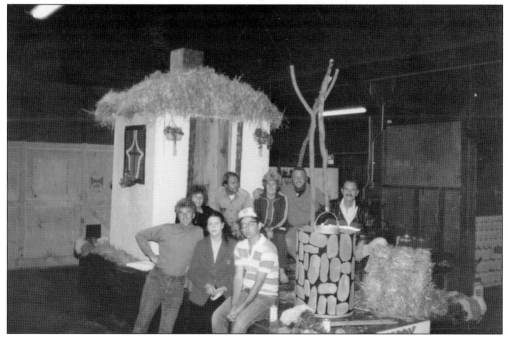

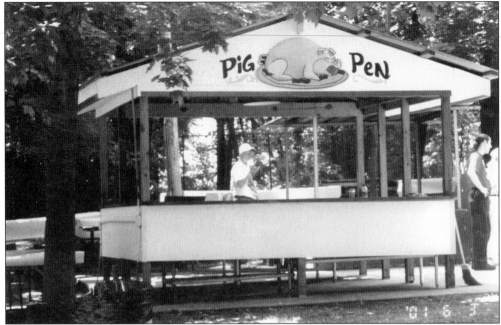

The Pig Pen at the St. Nicholas Byzantine Church picnic grounds is a popular booth during the parish's annual picnic. Joseph Bordas's family and friends help cook the pig. It takes 8 to 10 hours to roast the pig, depending on its size. The church's picnic started at Hathazi's Farm then moved to Endres's Farm. The picnics have been held for over 50 years. (Courtesy Mary Yurcisin.)

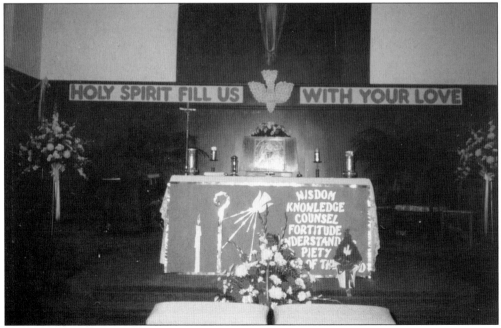

"Holy Spirit Fill Us with Your Love" was the theme for the confirmation class of Holy Assumption Church in 1986. A white dove made of flowers was placed under the risen Jesus. A banner with a candle, staff, and the Holy Spirit asks for wisdom, knowledge, counsel, fortitude, understanding, piety, and fear of the Lord for the class. (Courtesy Michelle Varga Scott.)

On Easter Sunday in 2001, parishioners of St. Nicholas Byzantine Church place their Easter baskets on the ground to be blessed by Father Wolf. Lent and fasting have ended, and the parishioners can celebrate by eating their ethnic foods. Easter breads called *paska*, homemade cakes, fresh ham, and fresh and smoked kolbasz fill the baskets for the parishioners to enjoy later for their Easter meal. (Courtesy Mary Yurcisin.)

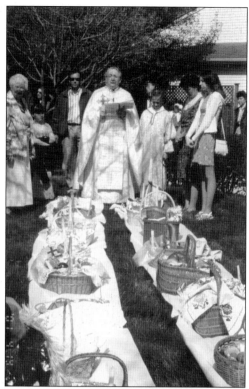

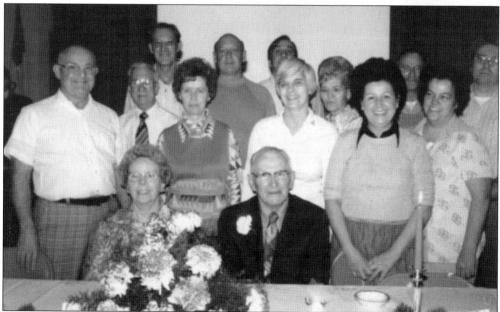

The 50th wedding anniversary of Anna and Roland Carty (seated) is celebrated on December 30, 1976, in the Trinity United Methodist Church. Standing behind the Cartys, from left to right, are (first row) Walter Nolan, Oscar Willman, Jeane Nolan, Marion McDowall, Grace Houseworth, Doris Paykos, and Marion Groze; (second row) Frank LeMunyon, Emmett Heintz, Paul Paykos, Alex McDowall, and Joe Twers. (Courtesy Marion McDowall.)

In 1997, Laura Schnell (left) and Doris Paykos of the Trinity United Methodist Church are pictured holding plaques in front of the church on Hornberger Avenue. A memorial plaque was installed in memory of Maury Schnell. The bell located under the sign was from one of the John A. Roebling's Sons Company steam locomotives used in the mill. (Courtesy Marion McDowall.)

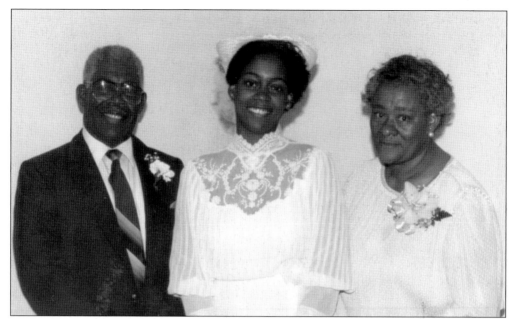

This photograph shows the Richardson family, from left to right, Earl, Donna, and Dorothy, before Donna exchanged marriage vows to Jeffrey Robinson in 1983. Earl is the son of Robert and Caroline Richardson, who moved to Roebling in 1915 and raised six boys and three girls. Earl and Dorothy are longtime Roebling residents and reside next door to where he was born in the Hoffner tract section of Roebling. (Courtesy Earl and Dorothy Richardson.)

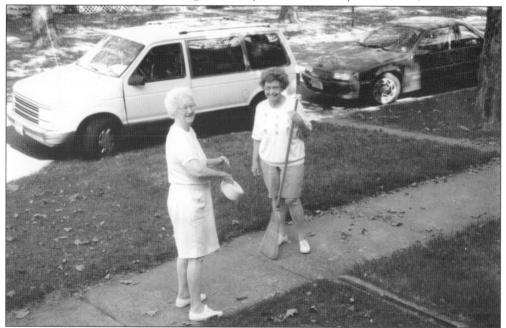

Kate Borbi (left) and Mary Arnold meet on Third Avenue in the summer of 1998. Longtime Roebling residents took pride in their homes, front yards, and sidewalks. They would sweep the stoops, rake leaves, and tidy up every day. While doing yard work, neighbors met and exchanged family news and events of the day. (Courtesy Louis Borbi.)

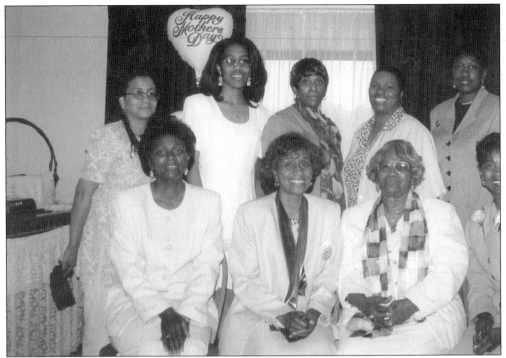

The family of Lula Jenkins celebrates Mother's Day 1992. Lula Boone Jenkins was born on Railroad Avenue and made it her home her entire life. From left to right are (first row) Willa Palmer, Geraldine Cawley, Lula Boone Jenkins, and Pat Miller; (second row) Colette Thomas, Crystal Boone, Sharon Linear, Joyce Jenkins, and Carla McLean. (Courtesy Lula Boone Jenkins.)

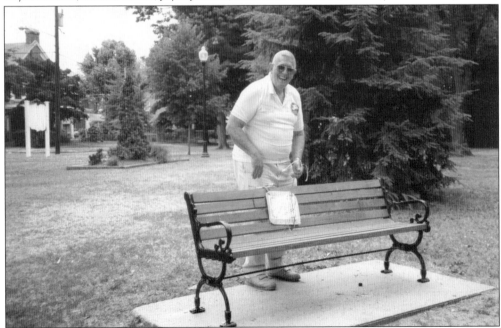

Frank Smith is pictured with the bench he and his wife, Flossie, donated to Roebling Park in the late 1990s. (Courtesy Paul and Loretta M. Varga.)

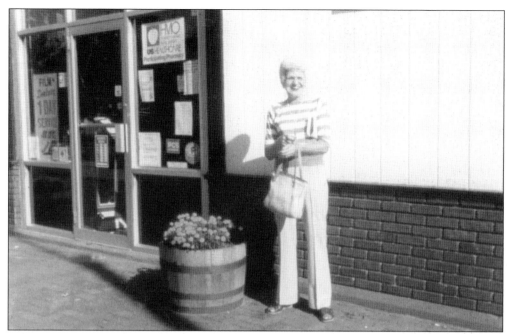

Delores Kish stands outside the Roebling Pharmacy located on the corner of Main Street and Fourth Avenue. Kish worked at the pharmacy from the time she was a teenager through her retirement. All the patrons enjoyed her friendly smile and helpful manner in the store. (Courtesy Louis Borbi.)

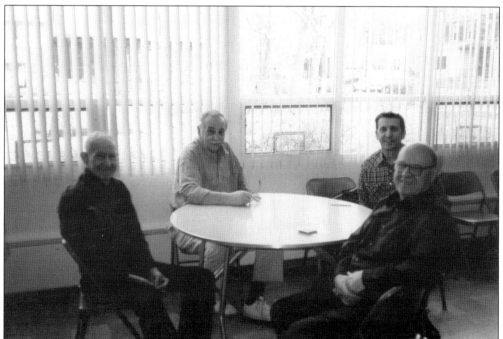

From left to right, "Red" Kincel, Ted "Riggs" Mariasy, Frank "Chick" Baldorossi, and Chester Swiderski meet in the old Union Hall, now the Florence Township Public Library, to discuss old times and to enjoy a game of cards in 1993. (Courtesy Louis Borbi.)

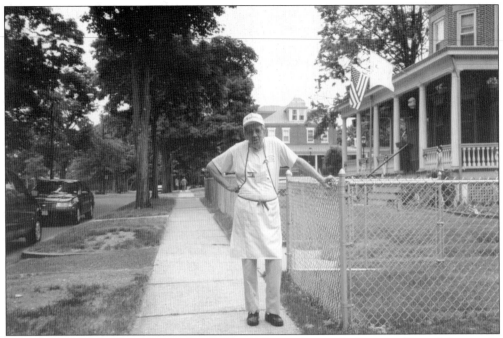

Ted Mitre stands in front of his Riverside Avenue home during the Patriotic Day celebration in 1999. Mitre was a longtime volunteer firefighter and served as chief of the department. He loves to cook for his family and friends, and his specialty is bacon bread. (Courtesy Ted Mitre.)

Joseph Bordas was a businessman in Roebling for over 40 years. He owned a butcher shop and Bordas' Liquors on Alden Avenue. (Courtesy Louis Borbi.)

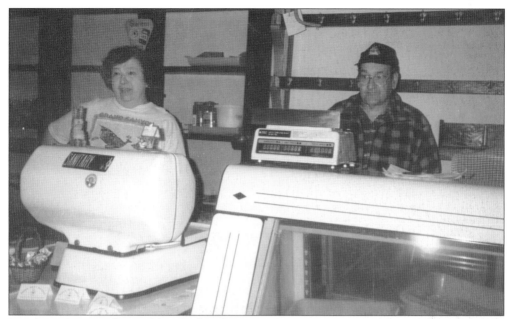

Josephine Szucs Nolan and her husband, Tom Nolan, are pictured in Szucs Meat Market on Alden Avenue. Originally the market was owned and operated by Josephine's father, John Szucs. He made smoked and fresh kolbasz and prepared bacon for bacon bread. He also sold grocery items and was in business over 50 years. The tradition continues with the Nolans, who now run the business. (Courtesy Joseph Varga.)

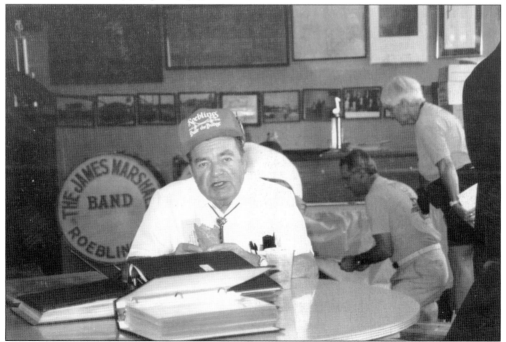

William (Bill) McGrath takes a break in the Pensioner's Room in the Florence Township Public Library. Behind McGrath to the left is the original drum from the James Marshall Band. On the right, Louis Borbi and Marion McDowall work on a project. (Courtesy Louis Borbi.)

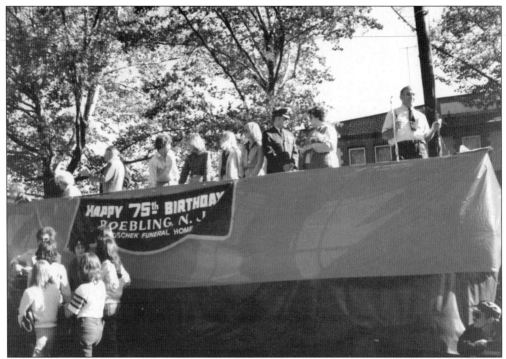

In 1980, one of the events for Roebling's 75th anniversary included a parade through the village. The photograph above shows the grandstand, which was sponsored by Koschek Funeral Home. In the photograph below, a parade float passes the Roebling Auditorium. (Courtesy Louis Borbi.)

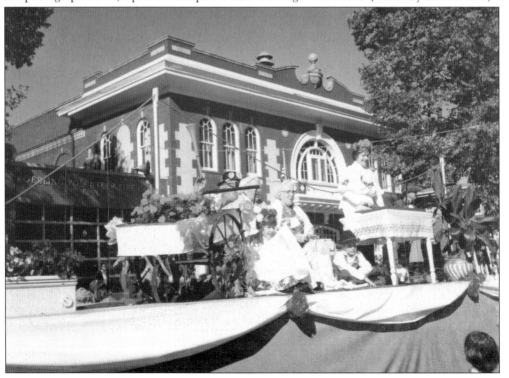

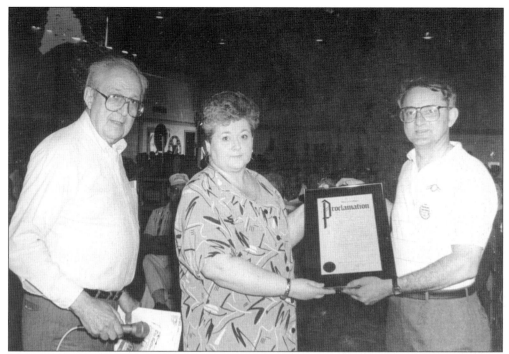

John Dimon (left) watches Mayor Sharon Worrell give Louis Borbi a proclamation in honor of the Founder's Day celebration. Borbi was recognized for heading the effort to preserve Roebling history and memorabilia by founding the Roebling Historical Society. (Courtesy Louis Borbi.)

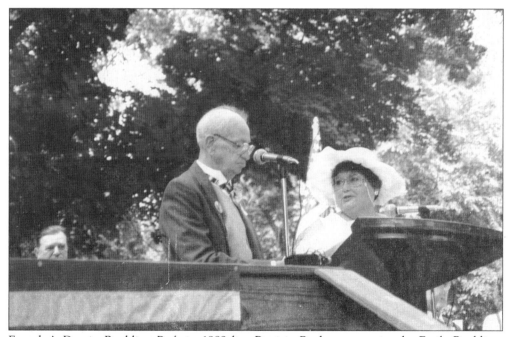

Founder's Day in Roebling Park in 1989 has Patricia Beahm portraying by Emily Roebling, talking to her husband, Washington Roebling, who was portrayed by Al Thomas. William McGrath is seated to the left of the couple. (Courtesy Louis Borbi.)

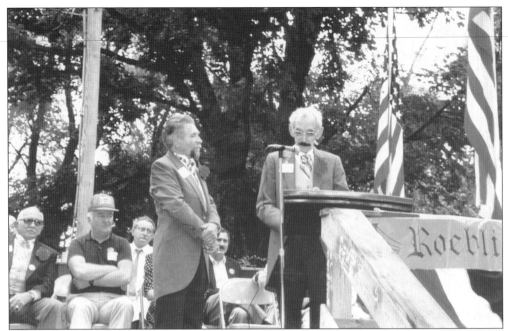

Paul Luyber (right), speaking in character as Charles G. Roebling, talks to Joseph Varga, who is portraying John A. Roebling, during Founder's Day festivities in Roebling Park in 1989. Seated from left to right are George Bucks, Ted Schildge, Louis Borbi, and Bruce Benedetti. (Courtesy Joseph Varga.)

From left to right, George Bucs, John Hodson, and Joseph Varga pose for this photograph on Founder's Day in 1989. The photograph was taken in the old Union Hall, which is now the Florence Township Public Library. (Courtesy Joseph Varga.)

Sharon Southard receives flowers for her effort with planning events from Roebling Historical Society president Louis Borbi at the Grape Dance held at St. Mary's Romanian Church Hall in 1989. The well-attended event saw guests wear ethnic costumes and enjoy great food, music, and dancing. (Courtesy Louis Borbi.)

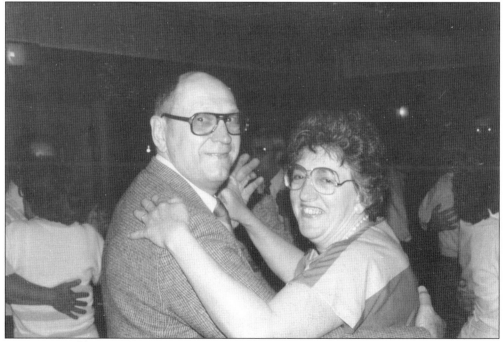

Longtime Roebling residents Paul and Loretta M. Varga dance at the Founder's Day Grape Dance in 1989. Both of these community-minded people have spent their time and effort promoting and beautifying the village of Roebling for many years. (Courtesy Louis Borbi.)

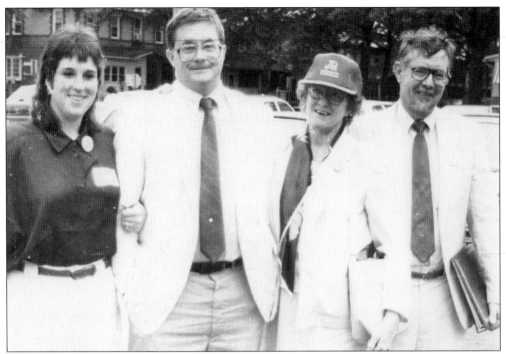

Wainwright "Rip" Roebling and family enjoy the festivities during Founder's Day in 1989. His wife, Eudora, is wearing a John A. Roebling's Sons Company–Roebling baseball cap. (Courtesy Louis Borbi.)

Ted Mitre's house on Riverside Avenue is decorated with patriotic flags and bunting on Founder's Day in 1989. (Courtesy Louis Borbi.)

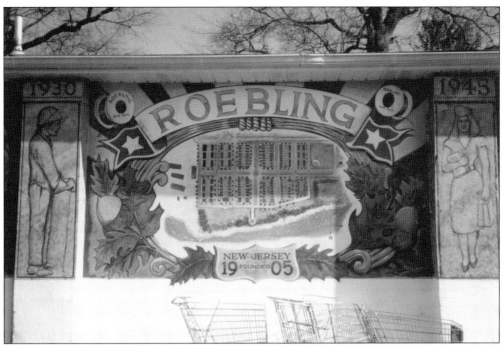

The Roebling Town Market (formerly the Shop-n-Bag) located on Hornberger Avenue features original murals painted by local artist Peter Bieling in 1993. The photograph above shows workers and an overview of the village. The photograph below shows a map of the United States with the locations of Roebling bridges and scenes pertinent to the John A. Roebling's Sons Company (Courtesy Louis Borbi.)

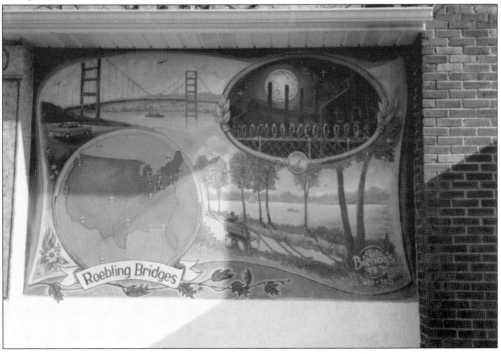

The first building constructed in Roebling, the Roebling Inn (above), and its carriage house (below) undergo a thorough rehabilitation in 1994. These buildings were beautifully refurbished for senior citizen housing and are located on Third and Riverside Avenues, near Roebling Park. (Courtesy Louis Borbi.)

Mitre's Grocery and Meat Market was located at the bottom of Alden Avenue. In the early days of the village, people would shop at the stores of their nationality to purchase the foods and spices they cooked with every day. Vasile Mitre was helpful to eastern Europeans who needed assistance bringing family members to America. The building was destroyed by fire in 2003. (Courtesy Louis Borbi.)

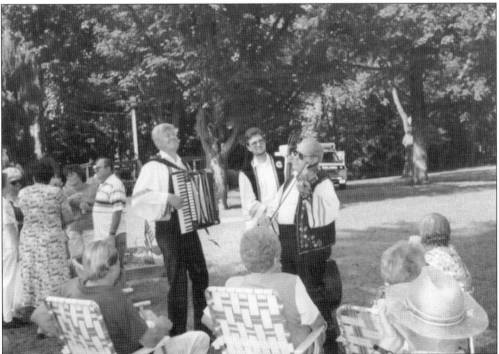

The Continental Gypsies, Rich Popso (left), Richard Popso Jr. (center), and Steve Fityere, entertain the visitors to Roebling Park in 1998. (Courtesy Paul and Loretta M. Varga.)

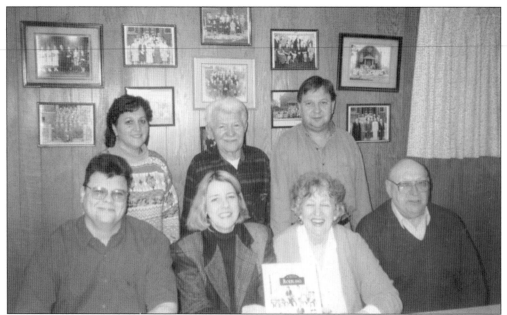

The Friends of Roebling of the Roebling Garden Club pose with their first book, *Roebling*. Pictured from left to right are (seated) Dan Roth, Rose M. Menton, Loretta M. Varga, and Paul Varga; (standing) Michelle Varga Scott, Joseph Varga, and Joseph B. Varga. Proceeds from the sale of the book have been used to purchase flowers and other items to beautify Roebling. (Courtesy Michelle Varga Scott.)

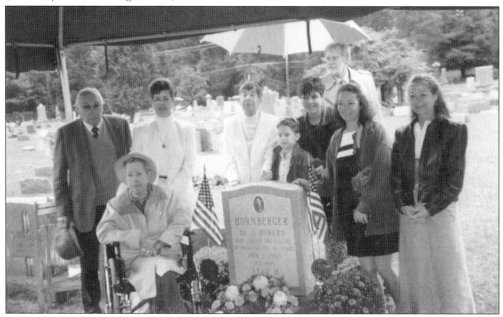

The Roebling Garden Club raised funds to purchase a headstone for longtime Roebling doctor J. Howard Hornberger. The headstone states that Hornberger served the village of Roebling for 40 years. On September 30, 2001, the day of the dedication, his family gathers around the headstone, which has a picture of him on the top. The grave is located at Cedar Hill Cemetery. (Courtesy Paul and Loretta M. Varga.)

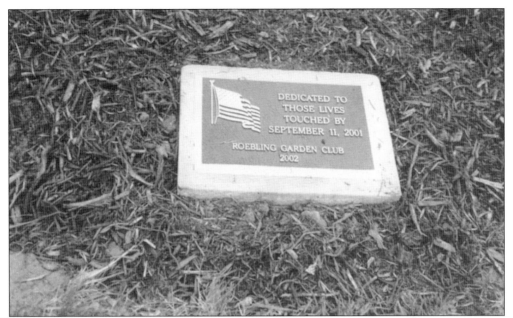

As with the rest of the country, Roebling was deeply affected by the tragic events of September 11, 2001. Headed by Roebling Garden Club vice president Harry Robinson Jr., a magnolia tree was planted and a plaque was placed in front of the Roebling Post Office at the Main Street Circle in 2002. The photograph above shows the plaque, which reads, "Dedicated to Those Lives Touched by September 11, 2001." The photograph below shows the magnolia tree and the plaque in the foreground, as the Florence Township Memorial Band performs in front at the post office. At the ceremony, members of the Roebling Rescue Squad spoke of their experiences in assisting with the rescue effort at the World Trade Center site in New York City. (Courtesy Paul and Loretta M. Varga.)

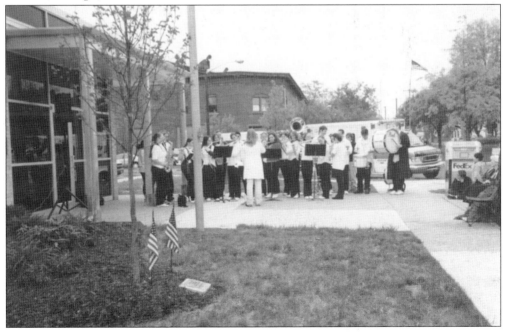

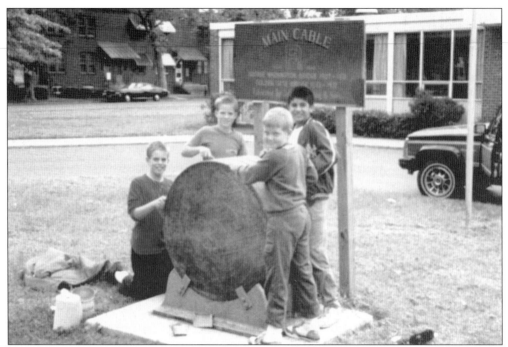

The photograph above pictures Roebling Elementary School students, from left to right, Brian Pukens, Andrew Holloway, Jason Hand, and Aashh Parekh working on scraping the main cable that is located in front of the Florence Township Public Library. The photograph below shows the students painting the cable international orange, which was the color of the Golden Gate Bridge, in 1987. (Courtesy Louis Borbi.)

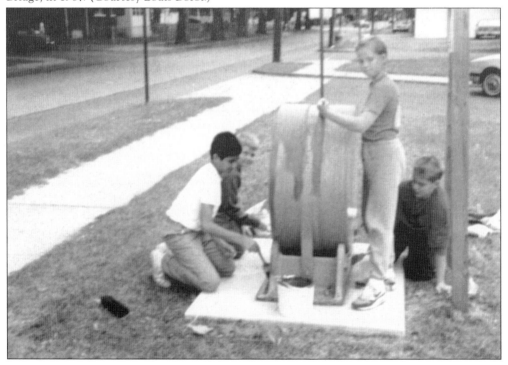

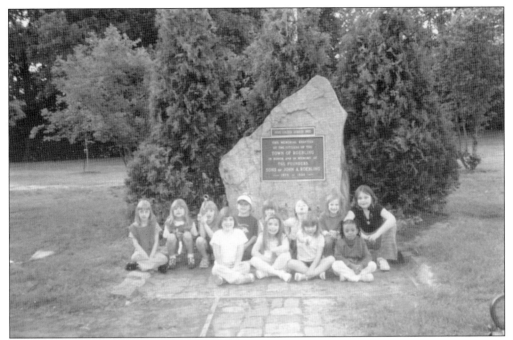

The local Brownie troop sits at the Roebling Monument after spending the day helping the Roebling Garden Club plant flowers around the monument in 2001. (Courtesy Paul and Loretta M. Varga.)

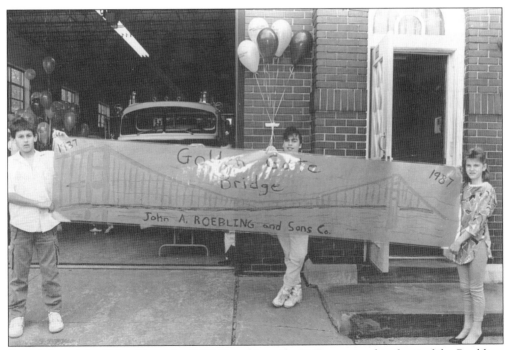

From left to right, Brian Opre, April Wolf, and Jennifer DeZutter stand in front of the Roebling firehouse in 1987. They are holding up a poster Louis Borbi's class made of the Golden Gate Bridge on the 50th anniversary of its construction. (Courtesy Louis Borbi.)

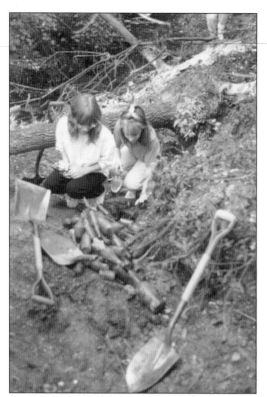

The photograph on the left shows Kristin Zingaro and Dana Ingham looking at the bottles the students unearthed on their archaeological dig behind the Florence Township Public Library in 1987. The village dump was located in the woods where the Roebling Arms now stands. In the photograph below, from left to right, Michael Neylan, Weston Morris, Jason Hand, Andrew Holloway, Bryan Puken, Allen Giroux, Aasrh Parekh, Michael Connelly, and Ed Hinton display their artifacts from their dig.

Winners for the Golden Gate Bridge poster contest from Holy Assumption School pose in the school lobby in 1987. Pictured from left to right are (first row) Megan Scott, Rodger Molnar, and Lisa Smith; (second row) Amy Stella, Kerri O'Hara, Brian Pietras, and Christina Machion. (Courtesy Michelle Varga Scott.)

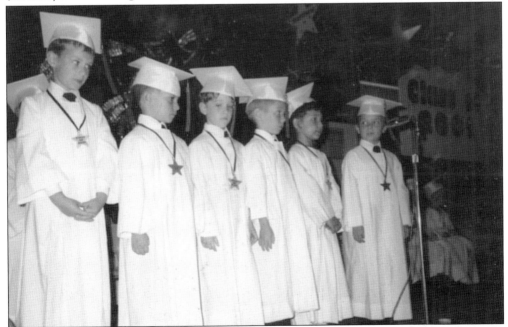

The Holy Assumption kindergarten graduating class of 1989 stands on stage in the school's cafeteria. Pictured from left to right are James Berry, Eric Zuno, Matthew Scott, C. J. Kessler, Sheila Delgadillo, and Justin Tettemer. Their graduation theme was "God's Shining Stars." (Courtesy Michelle Varga Scott.)

HOLY ASSUMPTION SCHOOL
MRS. FINN - GRADE 4

This photograph shows the fourth-grade class of Holy Assumption School from the 1992–1993 school year. Pictured from left to right are (first row) Erika Anderson, Heidi Kane, Paul Moran, Caron Boyd, Sheila Delgadillo, Jonathan Graver, and Holly Kane; (second row) C. J. Kessler, Jeffrey Carlani, Ashley Cote, David Wagner, Talina Cuozzo, Eric Swiderski, Matthew Scott, and David Yansick; (third row) teacher JoAnn Hewitt Finn, Joseph Pie´, Daniel Jones, Michael Lease, Eric Zuno, Matthew Botlinger, and Patrick Samulis. Among those pictured in the fourth row are Jessica Hendricks, Steven Tomosi, Justin Csik, Abdullah Abed, James Berry, Michael Botlinger, and Ryan Corcoran. (Courtesy Michelle Varga Scott.)

These students are somewhat eager on the first day of class in 1993 at the Roebling School. Pictured from left to right are Sean Pallas, Chris Larcome, Steve Ferenzi, Charles Whalen, Joe Millerline, Jason Marrazo, Chris Habeck, Mark Theurer, Michael Diehl, Matt Sturtevant, Justin Potpinka, and John Paoline. (Courtesy Louis Borbi.)

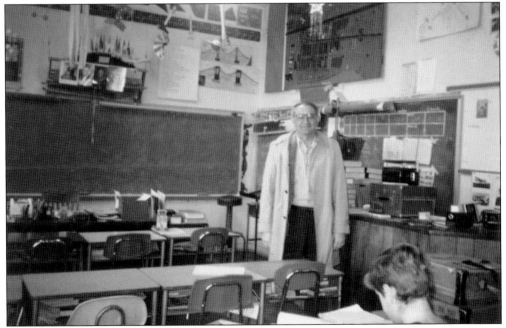

Pictured here is Louis Borbi in his classroom in 1993. Borbi taught for over 30 years, and during that time, students were encouraged to learn about the history of Roebling and the John A. Roebling's Sons Company. On display in the classroom are student-made projects and pictures of the Golden Gate and Brooklyn Bridges. (Courtesy Michelle Varga Scott.)

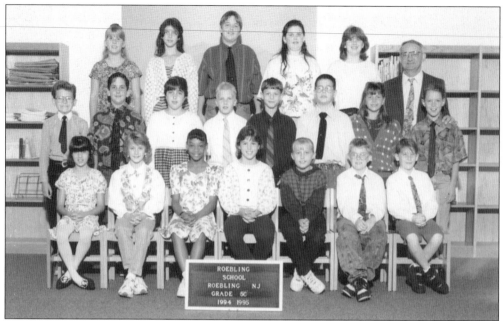

Roebling School's grade 5C poses for its 1994–1995 school year photograph. Pictured from left to right are (first row) Elisa Carroll, Patti Fluck, Dorian Jenkins, Brianna Murphy, Vanessa Kotch, Stephen Diehl, and George Traynor; (second row) J. R. Tetkoski. Andrew Butler, Lyndsay Schouck, Daniel Smith, Jacob Lederer, Matthew Cyples, Stacy Reynolds, and Colin McGurk; (third row) Jena Wyckoff, Gini Marisi, Chad Jacobsen, Hope Gordon, Megan Wilson, and teacher Louis Borbi. (Courtesy Louis Borbi.)

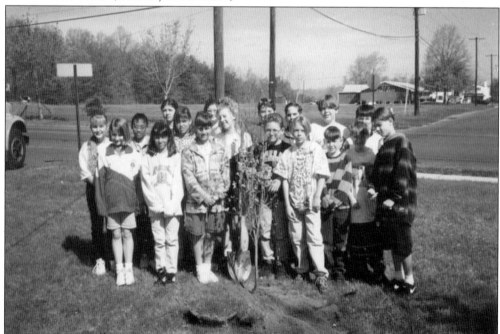

Roebling Elementary School students plant a tree in front of their school in loving remembrance of third-grade teacher Lillian LeDaux in the spring of 1995. (Courtesy Louis Borbi.)

National Honor students from Florence Township Memorial High School pose at the Main Street Circle after planting geraniums for Memorial Day in 2000. Pictured from left to right are (kneeling) Courtney Klinge, Matthew Scott, Jennel Entwistle, Jessica Fitzpatrick, and Alisa Paykos; (standing) Risa Frappolli, Kristin McCarter, Natalie Lipka, Jaclyn Mastin, Nicole White, Elisa Carroll, Kami Bernardo, and Mrs. Kruger holding her son. (Courtesy Paul and Loretta M. Varga.)

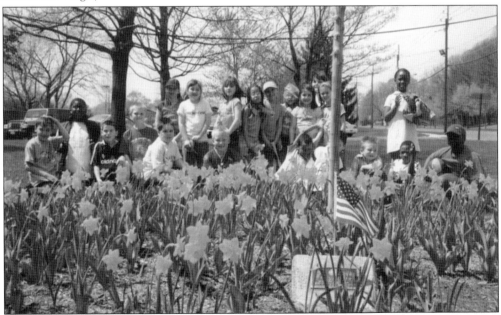

The second-grade students of Carol Borbi admire the daffodils blooming in the Garden of Hope in front of the Roebling Elementary School. The bulbs were planted on Veterans Day in 2003 along with "freedom trees." The trees were planted to remember William J. Hogan and Paul Willets, two hometown heroes who perished during World War I. (Courtesy Carol Tapper Borbi.)

Roebling Elementary School students measure the snowfall in 2004. Pictured clockwise from bottom right are Corey Wilson, Shenice Shafer, Frank Salinitro, Taylor Hutchinson, Kacey Kellerman, and Tianna Tucker. (Courtesy Sandy Paglione.)

Second-grade students from the Roebling Elementary School visit Roebling Station on the New Jersey Transit RiverLine. Pictured from left to right are Joe DeLorenzo, Anna Lombardo, and Taylor Belair. (Courtesy Sandy Paglione.)

Roebling Elementary School students proudly show the robots they constructed in 2004. Pictured clockwise from the top right are Kayla Berg, Anesha Cribbs, Da'von Williams, Samantha Cuevas, Kaleel Hampton, Alexis Ayala, and Steven Curlis. (Courtesy Sandy Paglione.)

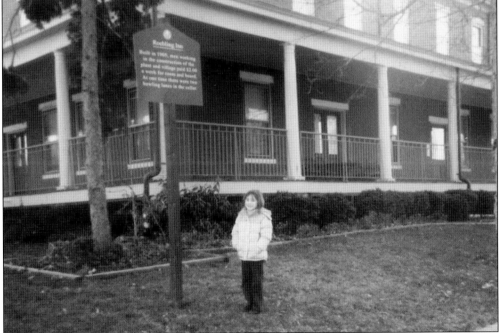

Daria Kate Sbraccia, age seven, is reading the sign outside the Roebling Inn. This building was one of the first buildings built in the village to provide housing for the mill workers. Today the inn is the home for many senior citizens. (Courtesy Mr. and Mrs. Joseph B. Varga.)

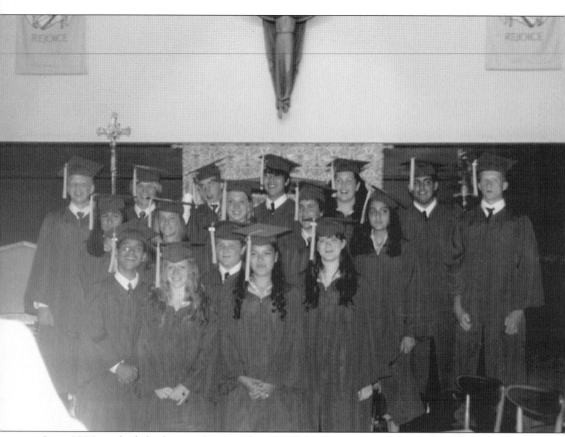

June 2006 marked the last graduating class for Holy Assumption School. Pictured from left to right are (first row) Andrew Idavoy, Kelsey Kapica, C. J. Boyd, Catherine Lopez, and Deanna Ulmer; (second row) Haneen Dahabreh, Brigitte Pastore, Emily Million, Eric Brown, and Ahblah Abed; (third row) Richard Brown, Ian Groover, Dylan Martin, Zachary Lee, Ashley LeBlanc, Abdul Abed, and Korey Linico. (Courtesy Rose M. Menton.)

Five

THE ROEBLING
CENTENNIAL

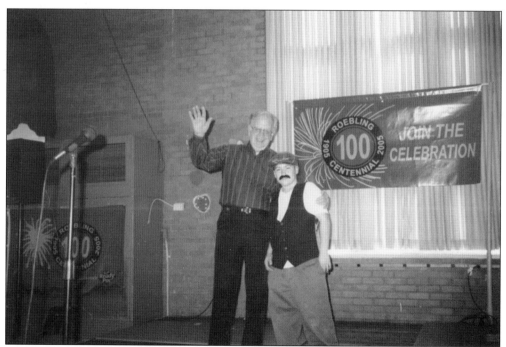

Robert Quig, a grandson of Jacob Hoffner, stands with Jacob Foehr, who portrayed Jacob Hoffner in the play "Roebling 1905–2005: The Centennial Play." Over 70 students from Roebling Elementary School, Marcella Duffy School, and Holy Assumption School performed in the play, written by Carol Tapper Borbi. Jacob Hoffner was the farmer who sold his farmland to Charles G. Roebling. (Courtesy Carol Tapper Borbi.)

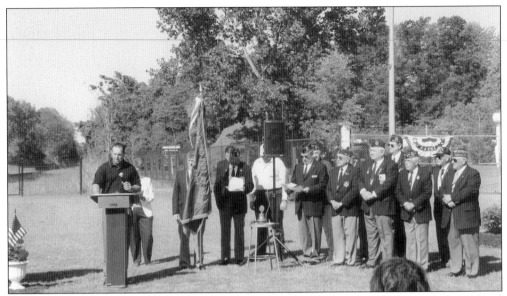

Florence Township Council member Frank K. Baldorossi Jr. stands at the podium as local veterans stand at the rededication of the World War II honor roll at Centennial Park in May 2005. (Courtesy Rose M. Menton.)

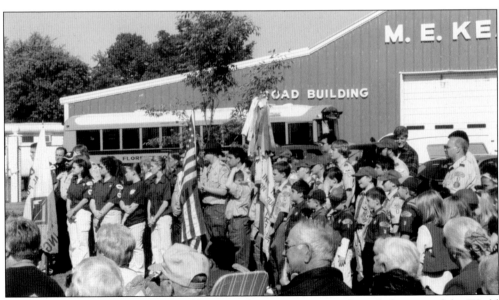

Local Boy and Girl Scouts stand and listen to the presentation at the rededication of the World War II honor roll. When the original honor roll was created in 1943, the Scouts raised the funds to design and build the honor roll. (Courtesy Rose M. Menton.)

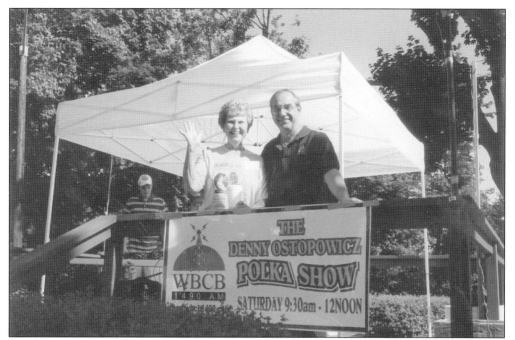

On June 18, 2005, the Roebling Centennial Committee sponsored an arts and crafts fair at Roebling Park. One of the highlights of the events was a live radio broadcast of the Denny Ostopowicz radio program during the fair. Roebling Centennial Committee chairperson Gail Tyree stands next to Ostopowicz. (Courtesy Rose M. Menton.)

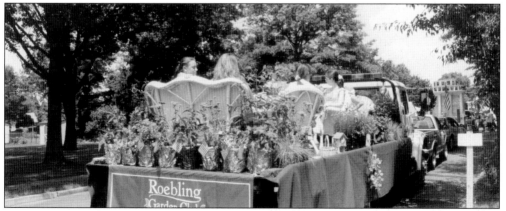

At the Patriotic Day parade in July 2005, the Roebling Garden Club's float is a summer garden party. Members of the garden club designed the float, which won first place in the parade's service category. Pagodin's Tree Care Service donated the flowers and plants, and J&S Automotive provided the float. (Courtesy Rose M. Menton.)

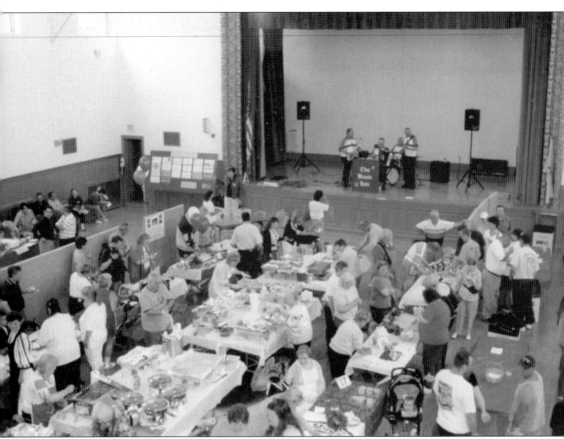

On May 21, 2005, the Roebling Centennial Committee sponsored the Stuffed Cabbage Cook-off contest as one of the centennial celebration events. It was a well-attended and tasty event. Cooks and tasters are pictured in the Roebling Auditorium. (Courtesy Rose M. Menton.)

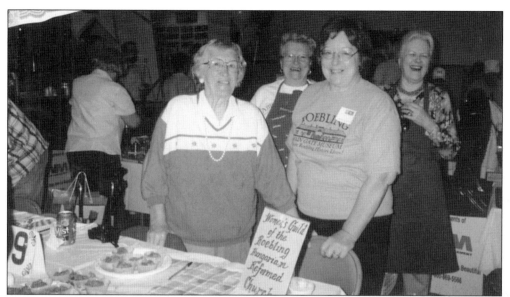

The ladies of the Women's Guild of the Hungarian Reformed Church of Roebling received first place in the organization division of the Stuffed Cabbage Cook-off. Pictured from left to right are Helen Bartha Bordash, Rose Bartha, Georgiana Bordash Harkel, and Corinne Varga, who worked at the competition representing all guild members who cooked for the contest. (Courtesy Michelle Varga Scott.)

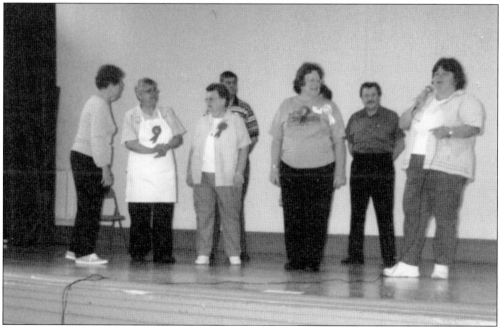

Roebling Centennial Committee chairperson Gail Tyree confers with the winners in the Stuffed Cabbage Cook-off held at the Roebling Auditorium. Pictured from left to right are Gail Tyree, Betty Sukola, Paula Ingham, Lonney Brown, Georgiana Bordash Harkel, Mickey Lubik, and Dinah Lee at the microphone. Lee coordinated the event, and winners were picked in several categories. Absent from the picture is Lena Awdiok. (Courtesy Michelle Varga Scott.)

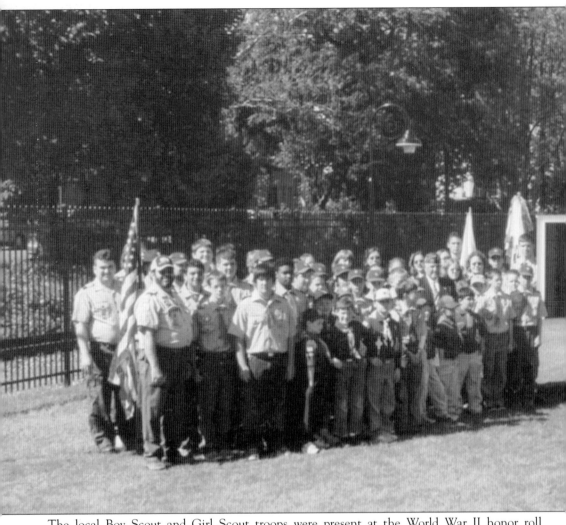

The local Boy Scout and Girl Scout troops were present at the World War II honor roll rededication. The Scouts reenact the photograph taken when the original honor roll was dedicated. Also present was the Florence Township Memorial Band, which performed patriotic

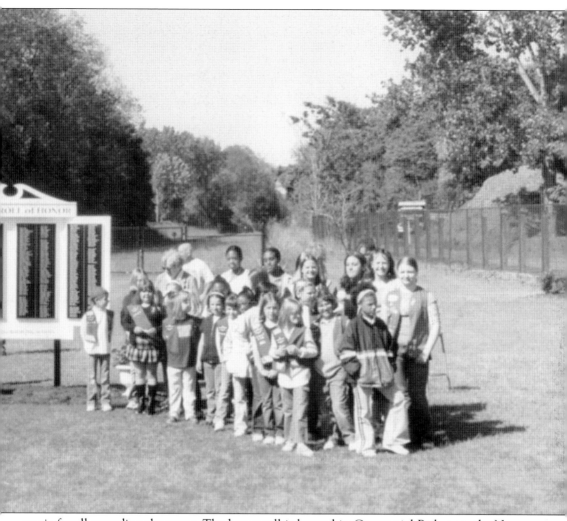

music for all attending the event. The honor roll is located in Centennial Park, near the New Jersey Transit RiverLine. (Courtesy Rose M. Menton.)

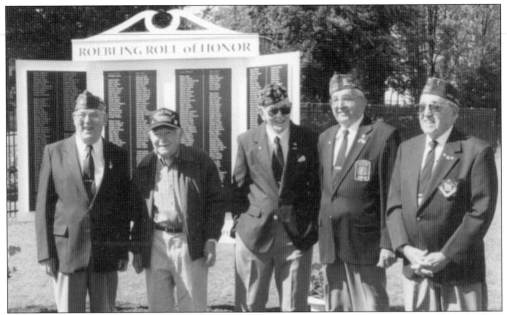

The Roebling Centennial Committee's rededication of the World War II honor roll took place on May 21, 2005. Members of Veterans of Foreign Wars pose in front of the honor roll. Pictured from left to right are Richard Glass, Joseph Varga, Thomas Gorse, Steve Mognancki, and Ernie Del Casino. The honor roll lists all the Roebling residents who served in World War II. (Courtesy Paul and Loretta M. Varga.)

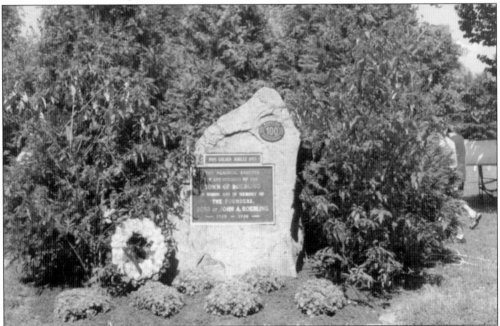

The Roebling Monument in Roebling Park now features the 100-year centennial plaque designed by local artist Don Jones and donated by John and Eleanor Hofflinger and the Roebling Garden Club. It joins the 25-year and golden jubilee plaques already on the monument. (Courtesy Paul and Loretta M. Varga.)

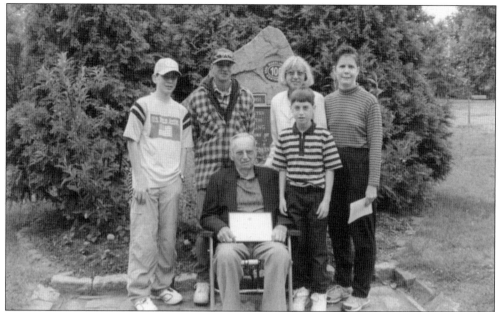

Julian "Buddy" Burr (seated) was among the Boy Scouts present at the dedication of the Roebling Monument on November 9, 1930. He was chosen to assist in the dedication because he was the only Scout in full uniform. Burr assisted in unveiling the 100th anniversary plaque on May 22, 2005. His son Doug and his wife, JoAnn, daughter Debbie, and grandsons Gregory and Zachary were present. (Courtesy Rose M. Menton.)

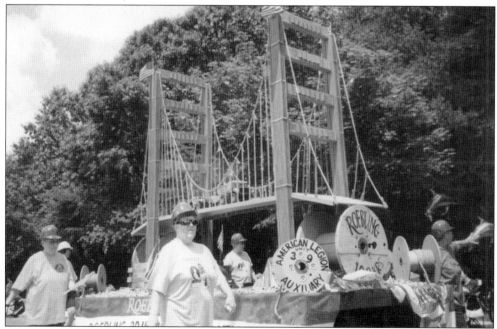

The ladies of America Legion Unit 39 Auxiliary walk beside their float in the Patriotic Day parade in 2005. Joan Horn, Judy Horn, Mary Ann Lathrop, Margo Miller Mattis, and Barbara Weinczyk constructed the replica of the Golden Gate Bridge. This beautiful float had replicas of Roebling wire reels and patriotic decorations. (Courtesy Carol Tapper Borbi.)

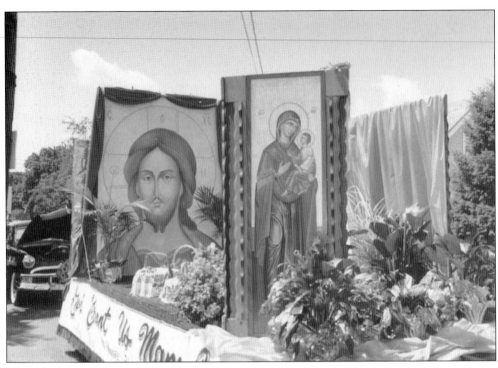

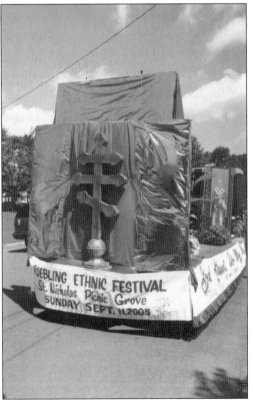

David Jakim painted the beautiful pictures that adorned the St. Nicholas Byzantine Church's float in the 2005 Patriotic Day parade. Joe Bordas, Blake Dimon, John Jakim, and Mary Ann Yurcisin assisted him. The float displays the religious figures and the Byzantine cross and asks, "God Grant Us Many Years." The photographs above and at left show different views of the floats. (Courtesy Mary Yurcisin.)

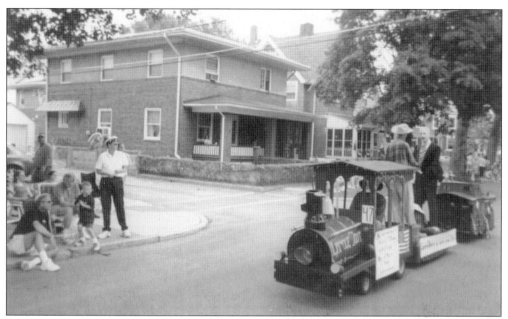

The 2005 Patriotic Day parade featured *Little Toot*, a train owned by Joseph Varga Electrical Service. The train features statues of Charles G. Roebling and Jacob Hoffner, highlighting the sale of Hoffner's farmland to John A. Roebling's Sons Company. This picture was taken on Main Street heading toward the reviewing stand. The train has been in the Patriotic Day parades since 1976. (Courtesy Joseph Varga.)

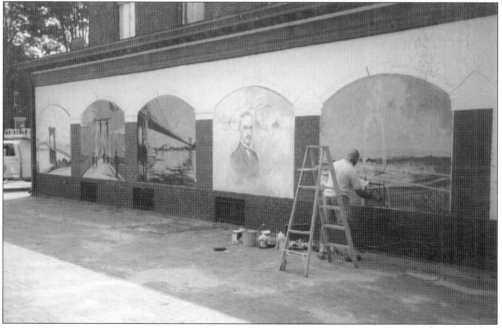

Artist Morris Docktor paints murals on the Fourth Avenue side of an old Roebling building. Originally this building housed the fire wagon, and it was a pharmacy for many years. Docktor has an image of the village's founder, Charles G. Roebling, and bridges that were Roebling-made. (Courtesy Paul and Loretta M. Varga.)

In the photograph above, Roebling family descendent Bill Roebling, Loretta M. Varga (center), and Gail Tyree enjoy the Occasion in the Park in September 2005. Pictured below are, from left to right, Wainwright "Rip" Roebling, Loretta M. Varga, Mary Roebling Foster, and Eudora Roebling. Wainwright and Mary are Roebling family descendents. (Courtesy Rose M. Menton.)

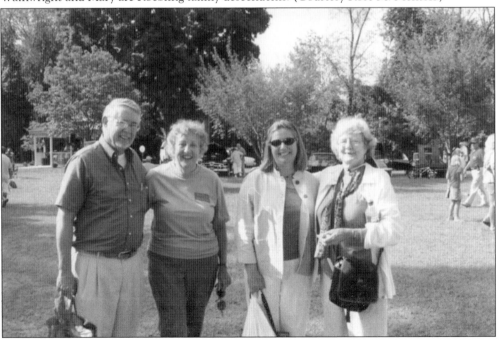

The corner of Seventh Avenue and Main Street, home of Mr. and Mrs. Joseph B. Varga, shows statues of Charles G. Roebling and Jacob Hoffner. The statues, created by Joseph Varga, were in the 2005 Patriotic Day parade on a float pulled by Varga's train *Little Toot*. The statues are a focal point, encouraging people to purchase pavers for the Charles G. Roebling statue. (Courtesy Joseph Varga.)

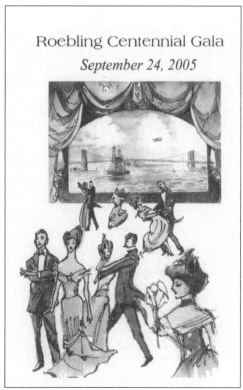

The Roebling Centennial Gala was the crowning event of a 12-month celebration. Over 200 people attended the event in the Roebling Auditorium. Remarks were made by committee members Dennis O'Hara, George Lengel, Gail Tyree, Linda O'Hara, and Donna DiPaola Frappolli. Mayor Michael Muchowski spoke, and Fr. Felix Venza gave an invocation. Local artist Donald Jones designed the cover of the program, which shows the Brooklyn Bridge curtain that was in the Roebling Auditorium. (Courtesy Rose M. Menton.)

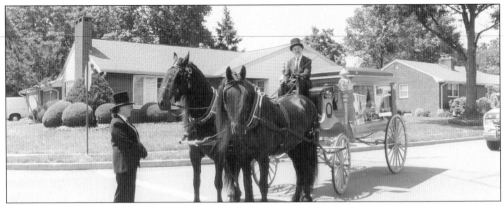

For its entry in the 2005 Patriotic Day parade, Koschek and Porter Funeral Home provided a vintage horse-drawn hearse with horsemen wearing top hats. This entry was one of the favorites in the parade. (Courtesy Rose M. Menton.)

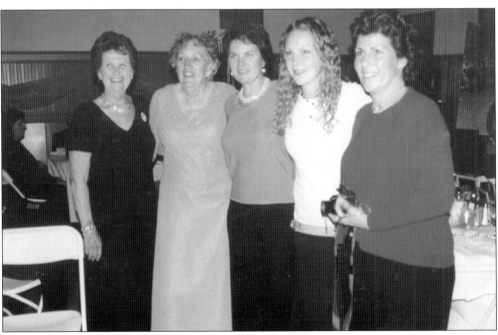

The photograph shows, from left to right, Roebling Centennial Committee chairperson Gail Tyree, committee member Loretta M. Varga, and Roebling family descendents Catherine Dodge, Erin McDonald, and Linda McDonald during the festivities at the Roebling Centennial Gala. (Courtesy Rose M. Menton.)

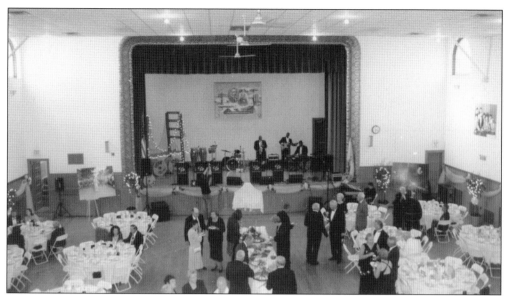

These pictures show the view from the balcony in the Roebling Auditorium on September 24, 2005, during the Roebling Centennial Gala. Pictures of Roebling's history adorned the walls, and a model of the Golden Gate Bridge was on the stage. The elegant affair had a parade of flags representing the home nationalities of Roebling residents while "Coming to America" was performed by CTO Park Avenue. (Courtesy Rose M. Menton.)

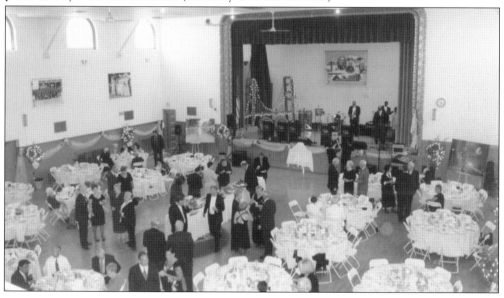

ACROSS AMERICA, PEOPLE ARE DISCOVERING SOMETHING WONDERFUL. THEIR HERITAGE.

Arcadia Publishing is the leading local history publisher in the United States. With more than 3,000 titles in print and hundreds of new titles released every year, Arcadia has extensive specialized experience chronicling the history of communities and celebrating America's hidden stories, bringing to life the people, places, and events from the past. To discover the history of other communities across the nation, please visit:

www.arcadiapublishing.com

Customized search tools allow you to find regional history books about the town where you grew up, the cities where your friends and family live, the town where your parents met, or even that retirement spot you've been dreaming about.

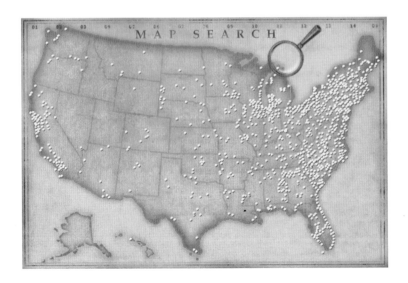